Happy 50TH !

Jan + phil

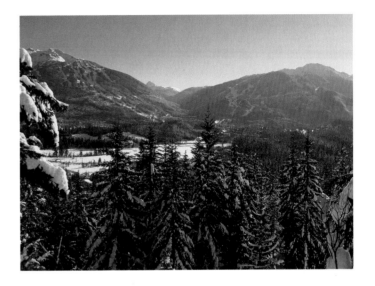

WHISTLER

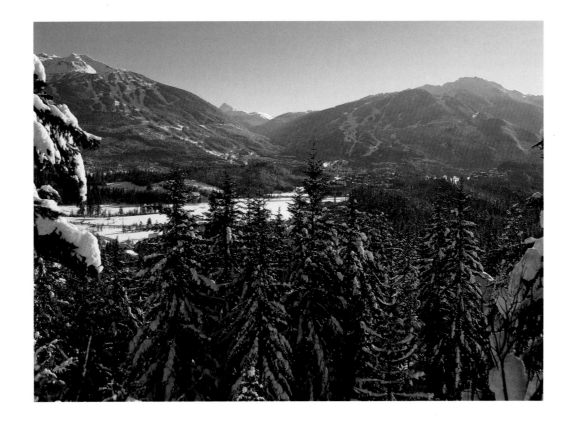

WHITECAP BOOKS

The information in this book is true and complete to the best of our knowledge. All
recommendations are made without guarantee on the part of the author or Whitecap
Books Ltd. The author and publisher disclaim any liability in connection with the use
of this information. For additional information please contact Whitecap Books Ltd.,
351 Lynn Avenue, North Vancouver, British Columbia, Canada, V7J 2C4.

Text by Tanya Lloyd Kyi
Edited by Elaine Jones
Proofread by Lisa Collins
Cover and interior design by Steve Penner
Cover layout by Jacqui Thomas

Printed and bound in Canada

National Library of Canada Cataloguing in Publication Data

Kyi, Tanya Lloyd, 1973–
 Whistler

 (Canada series)
 ISBN 1-55110-857-7

 1. Whistler (B.C.)—Pictorial works. I. Title.
FC 3849.W49L66 1999 971.1'31 C98-911022-2
F1089.5.W49L66 1999

The publisher acknowledges the financial support of the Government of Canada through
the Book Publishing Industry Development Program for our publishing activities.

For more information on the Canada Series and other Whitecap Books
titles, please visit our web site at www.whitecap.ca.

Whistler strikes a balance between recreation and relaxation that draws a million visitors a year to the alpine region north of Vancouver, British Columbia. From extreme skiing on the slopes of Blackcomb to a day at the Chateau Whistler's spa, the resort can cater to every whim.

Since the early twentieth century, when passengers on the Canadian Pacific Railway could book a week-long fishing vacation at Rainbow Lodge for two dollars, the Whistler region has been drawing adventure-seekers. While skiing and snowboarding dominate the winter, summer brings windsurfing, rafting, sailing, and mountain biking. None of these appeal? Hit the slopes again, even in July. Blackcomb is the only mountain in North America to offer lifts to year-round skiing. The Horstman Glacier boasts 45 hectares of prime conditions.

Part of what makes Whistler so appealing is its setting in one of the continent's most spectacular mountain ranges. Created by ancient volcanic activity, rock formations such as Black Tusk and Stawamus Chief dominate the landscape. In fact, the mountains are still being shaped as glaciers carve their way down many of the peaks. This scenery, along with the chance to see eagles, marmots, and even the occasional black bear, is what attracts scores of hikers and backpackers to the area each summer.

Whatever activity you choose, you'll soon find yourself immersed in Whistler Village's easygoing atmosphere. Lively music from an outdoor café will pull you in, and before you know it, you'll be taste-testing in one of more than a hundred bars and restaurants, shopping in an up-scale boutique, or chatting up the local snowboarders at the base of the gondola. Whistler was designed as a resort destination—it's impossible not to have fun.

Breathtakingly steep drops challenge even the most experienced skiers. About twenty percent of the runs at Whistler/Blackcomb are designed for experts.

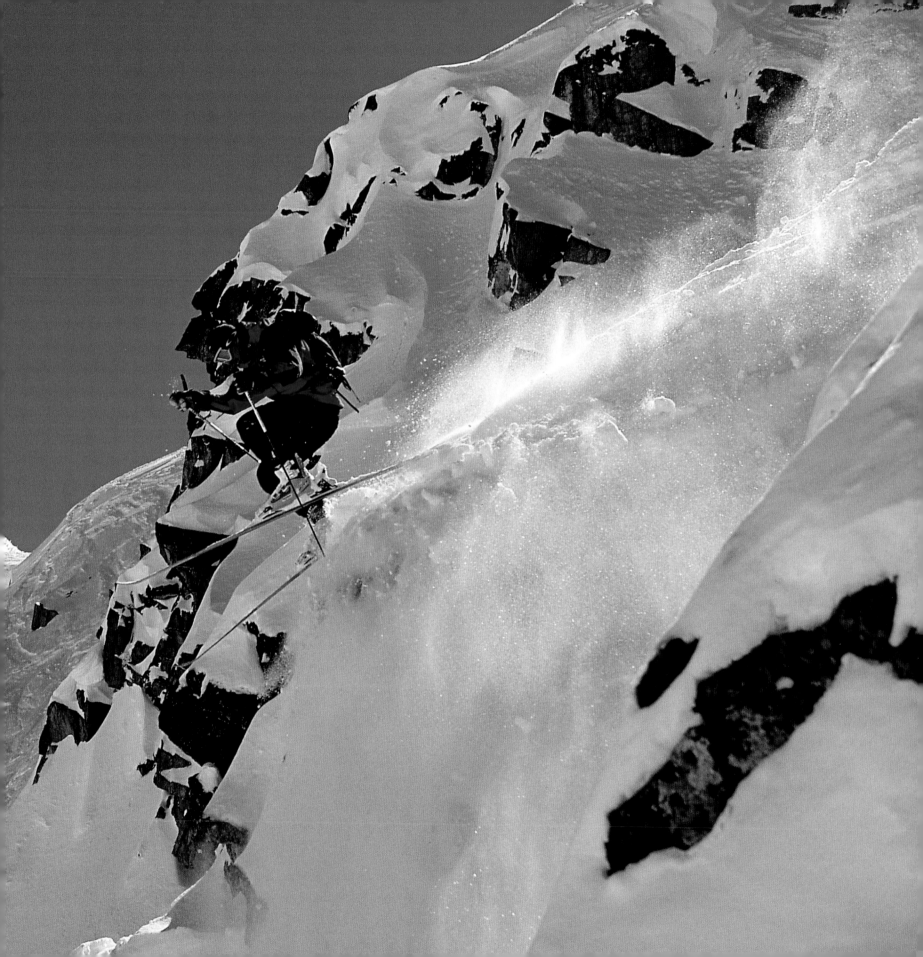

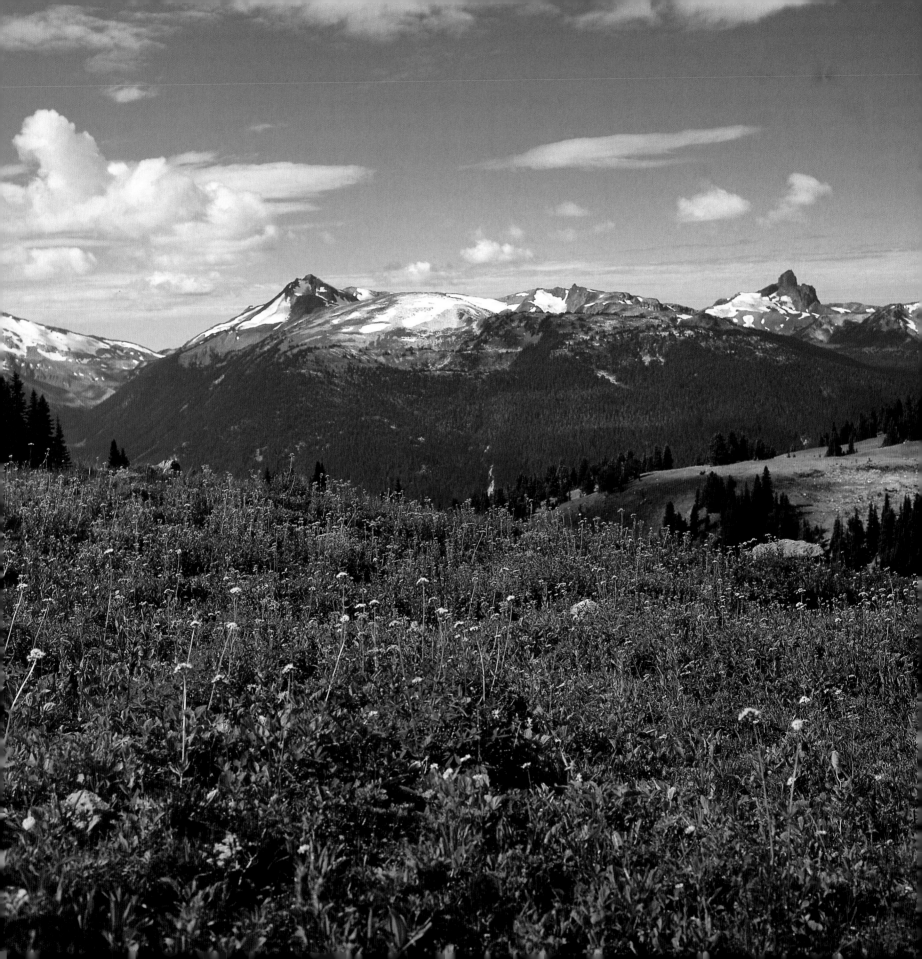

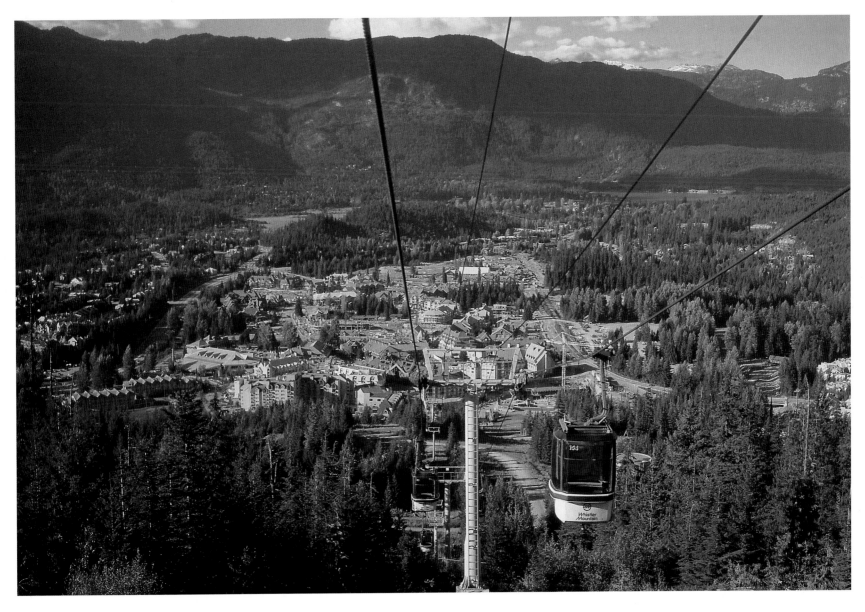

Blackcomb and Whistler have the highest vertical rises of any ski mountains in North America. Whistler rises 1530 metres and Blackcomb reaches 1609 metres—one vertical mile.

Wildflowers cloak the alpine meadows throughout the summer.

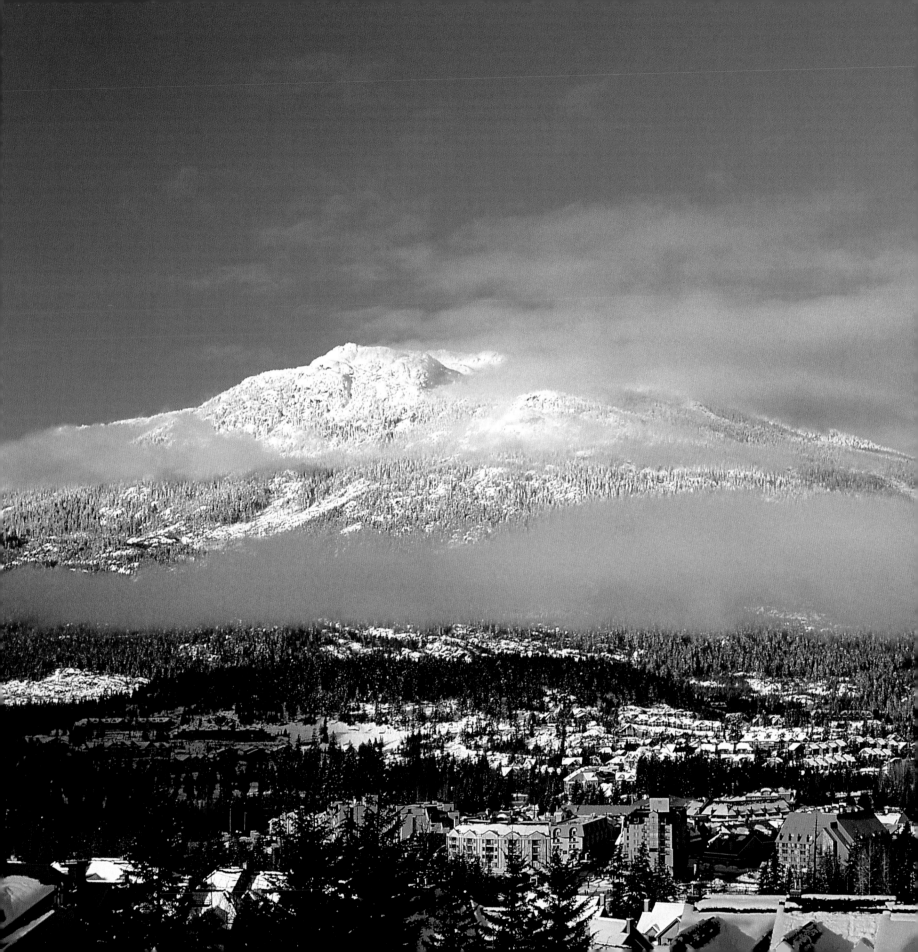

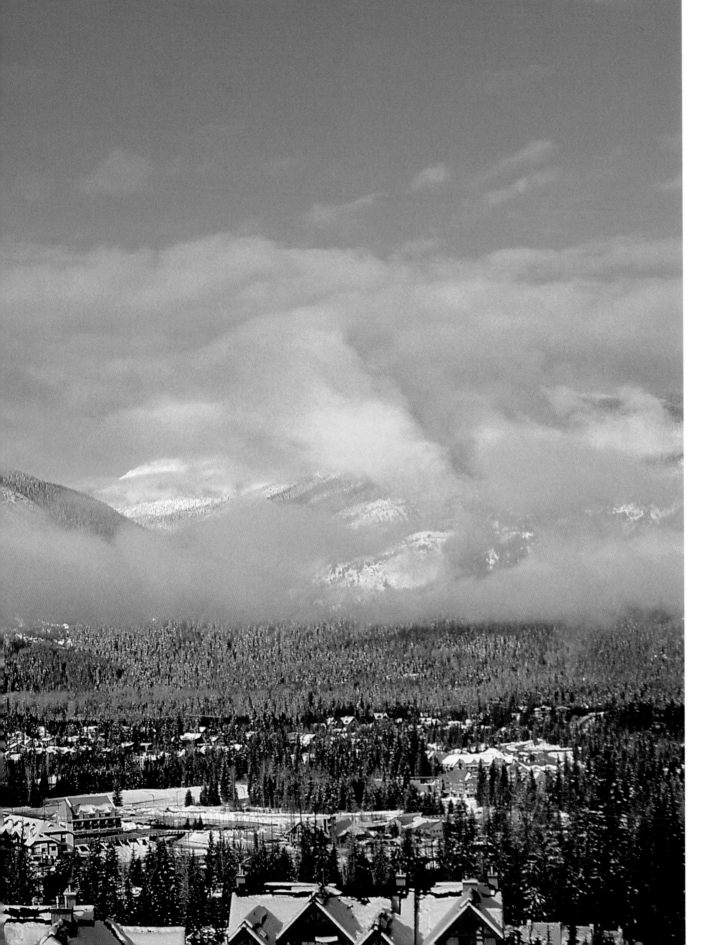

Whistler's reputation as a resort destination began in 1914, when Alex and Myrtle Philip opened Rainbow Lodge, a fishing retreat on the shores of Alta Lake. Other early attractions included the Hillcrest, Cypress, and Jordan lodges.

Three gondolas, ten high-speed quads, six triple chairs, one double, and twelve surface lifts speed visitors up and down the mountains.

FACING PAGE—
Helicopter tours offer panoramic views of glaciers, crevasses, and granite peaks.

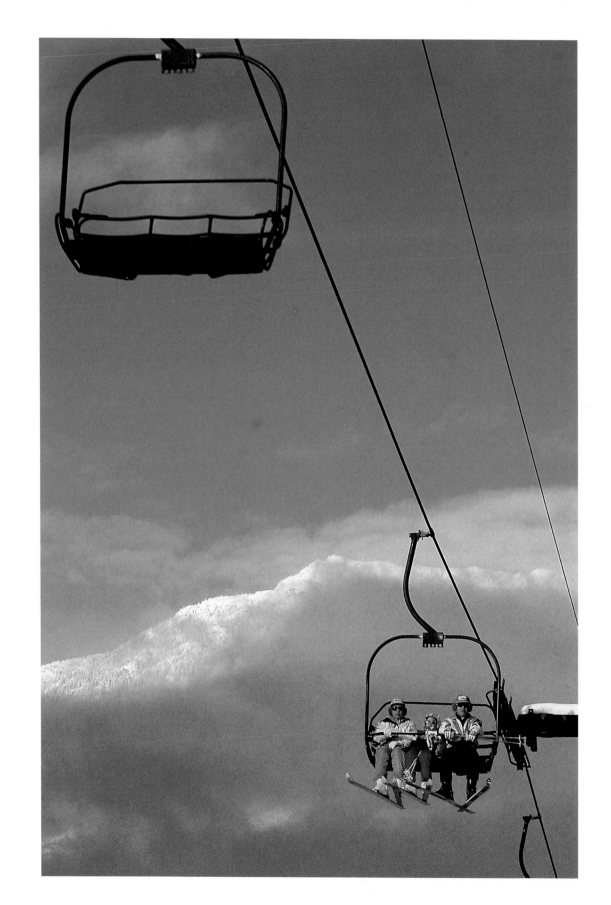

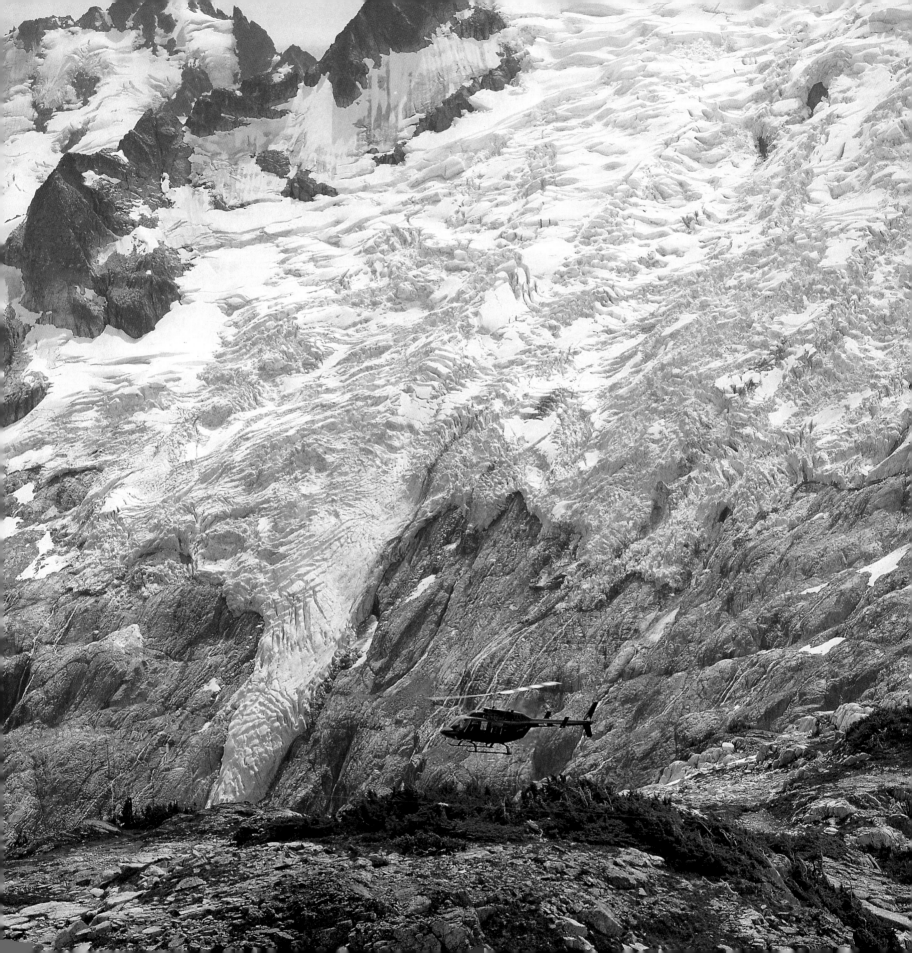

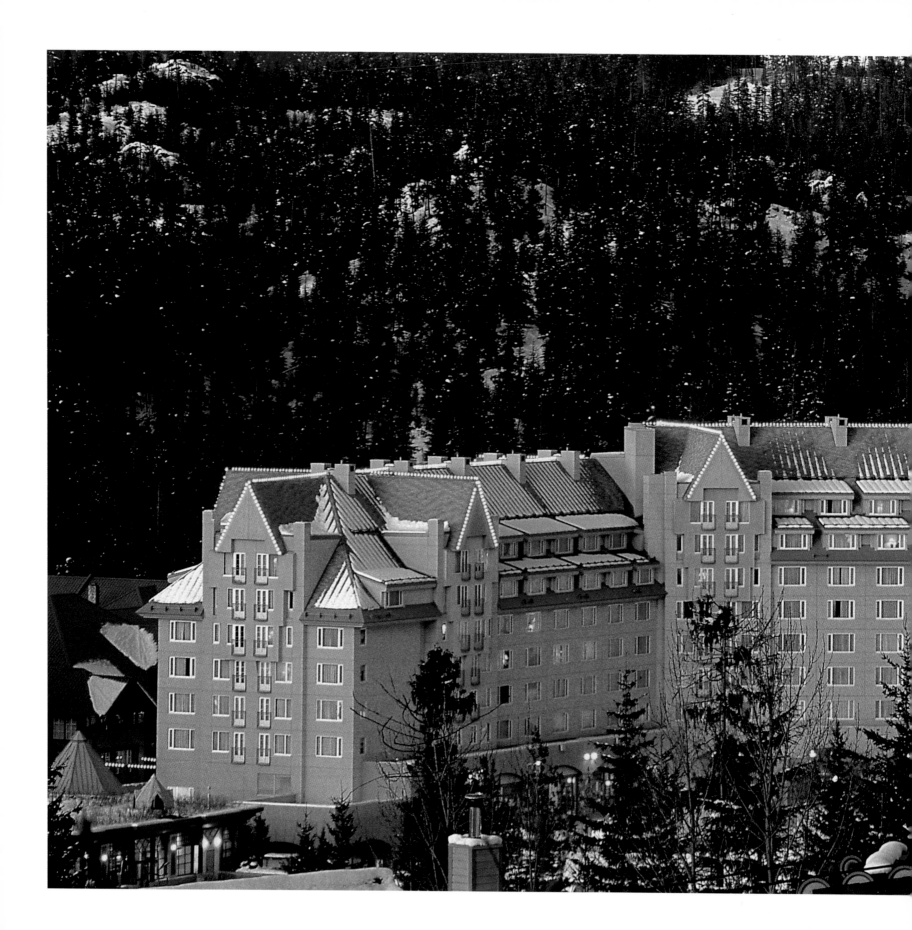

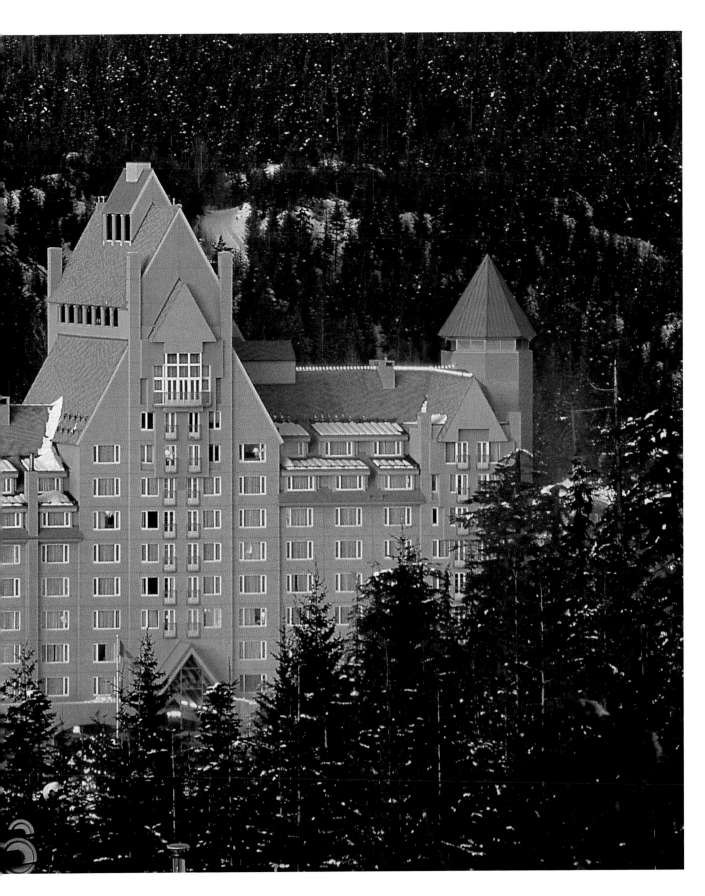

The first hotel built
by Canadian Pacific
in almost a century,
the Chateau Whistler
boasts its own golf
course, tennis courts,
health club, and spa.
This luxury hotel is
billed as a resort
within a resort.

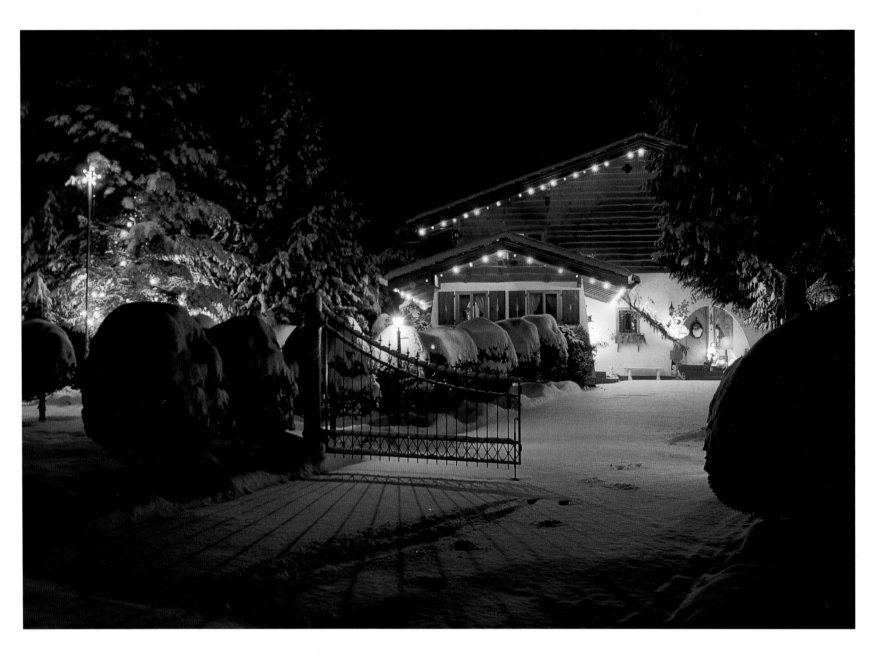

Lit by Christmas lights and surrounded by snowdrifts, Whistler
homes seem to capture the spirit of the season. Skating, tobogganing,
and carolling make Christmas here an unforgettable experience.

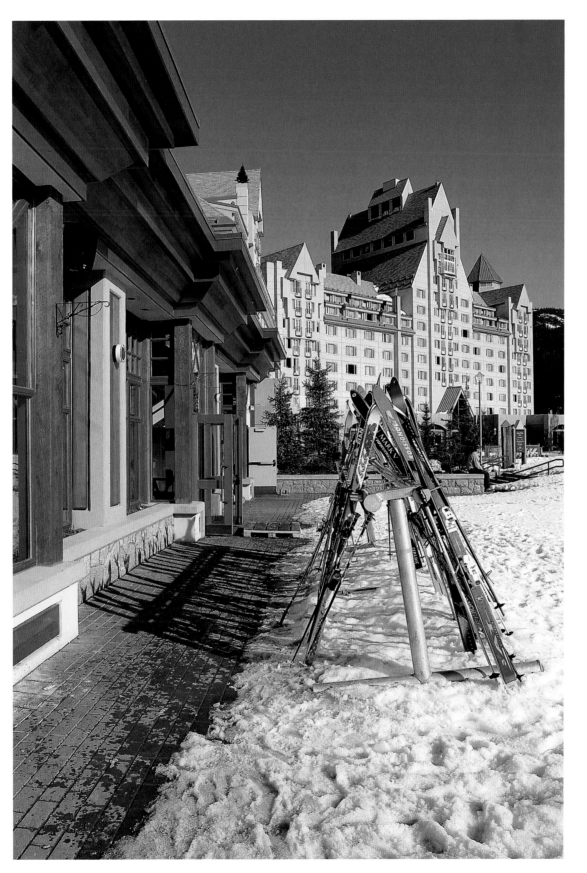

When the Garibaldi Lift Company first opened its doors on Whistler Mountain in 1966, a lift ticket cost five dollars. About 5000 skiers a day visited in 1974. Now, lifts can carry 50,000 people an hour.

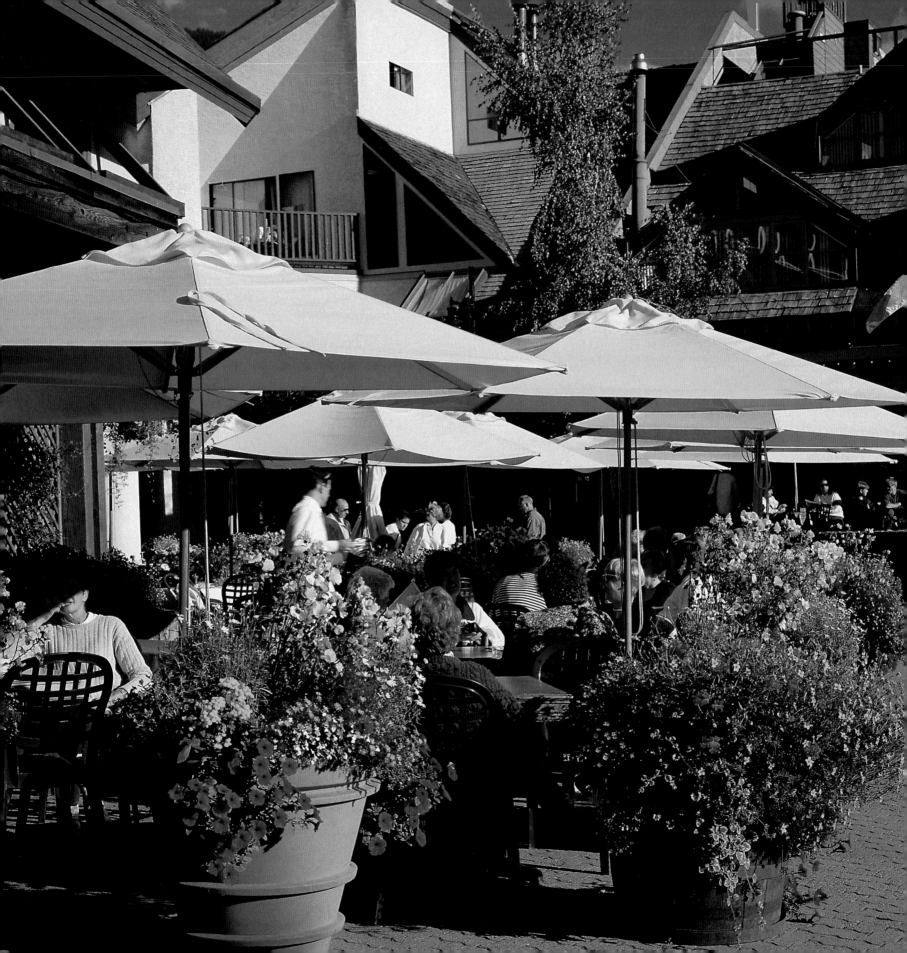

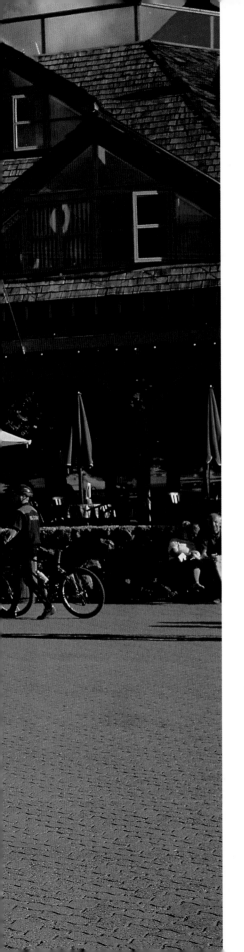

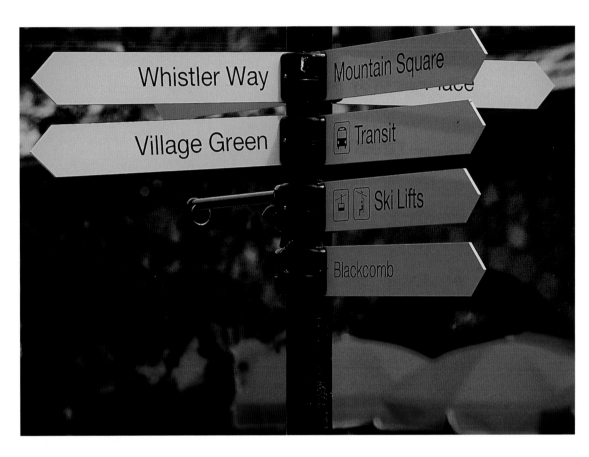

Whistler Way

Mountain Square

Village Green

Transit

Ski Lifts

Blackcomb

Colourful signs identify pedestrian squares and lanes.

European-style patios and terraces line the
village streets. More than a hundred bars
and restaurants offer everything from sushi
and dim sum to moussaka and satay.

Though Whistler has only about 8000 full-time residents, there are often more than 40,000 visitors in the village. In total, more than a million people visit each year.

FACING PAGE—
The first condominium was built here in 1965. Units sold for under $10,000. The village now has more lodging on the sides of the slopes than any other resort on the continent.

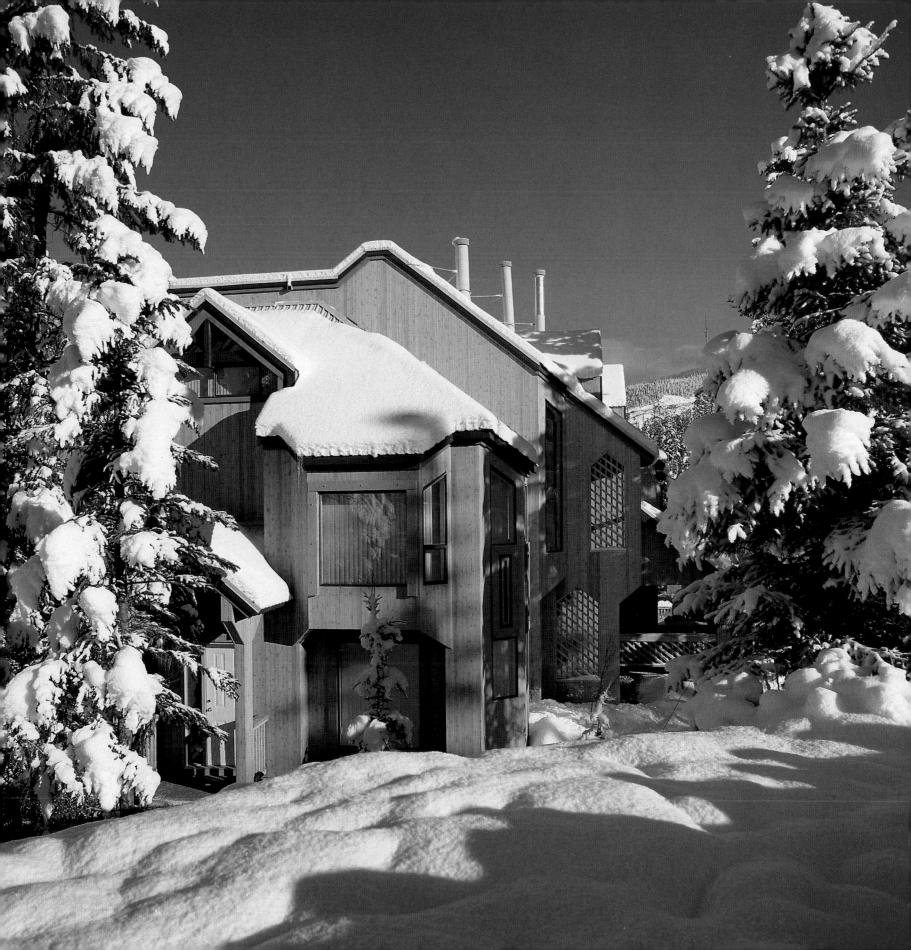

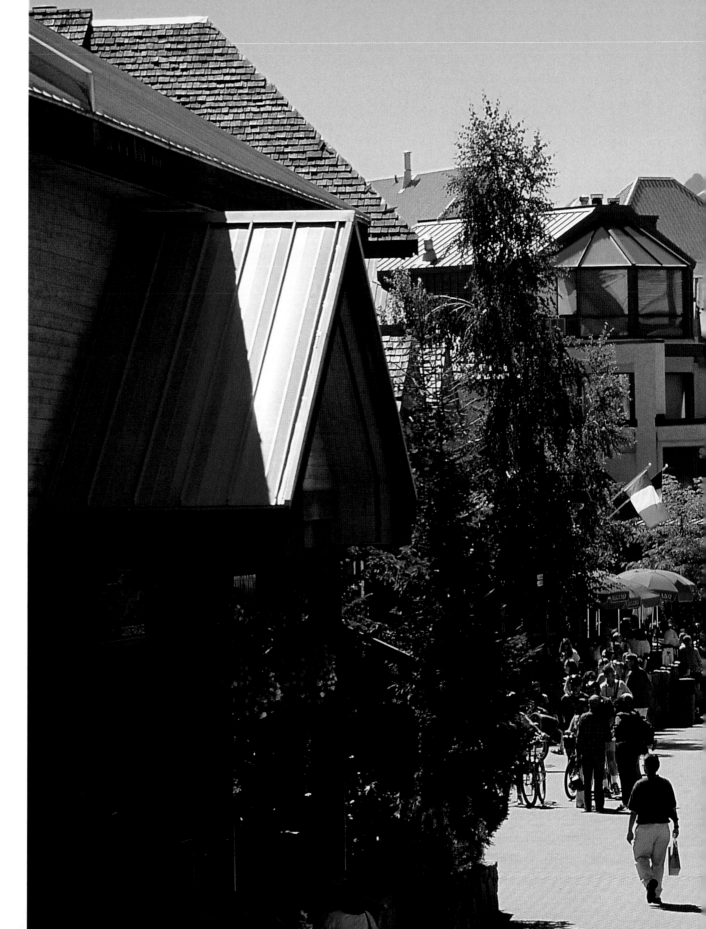

Careful community planning has ensured a cheerful, easygoing atmosphere in the village. Pedestrians can wander freely between shops and restaurants on pedestrian malls.

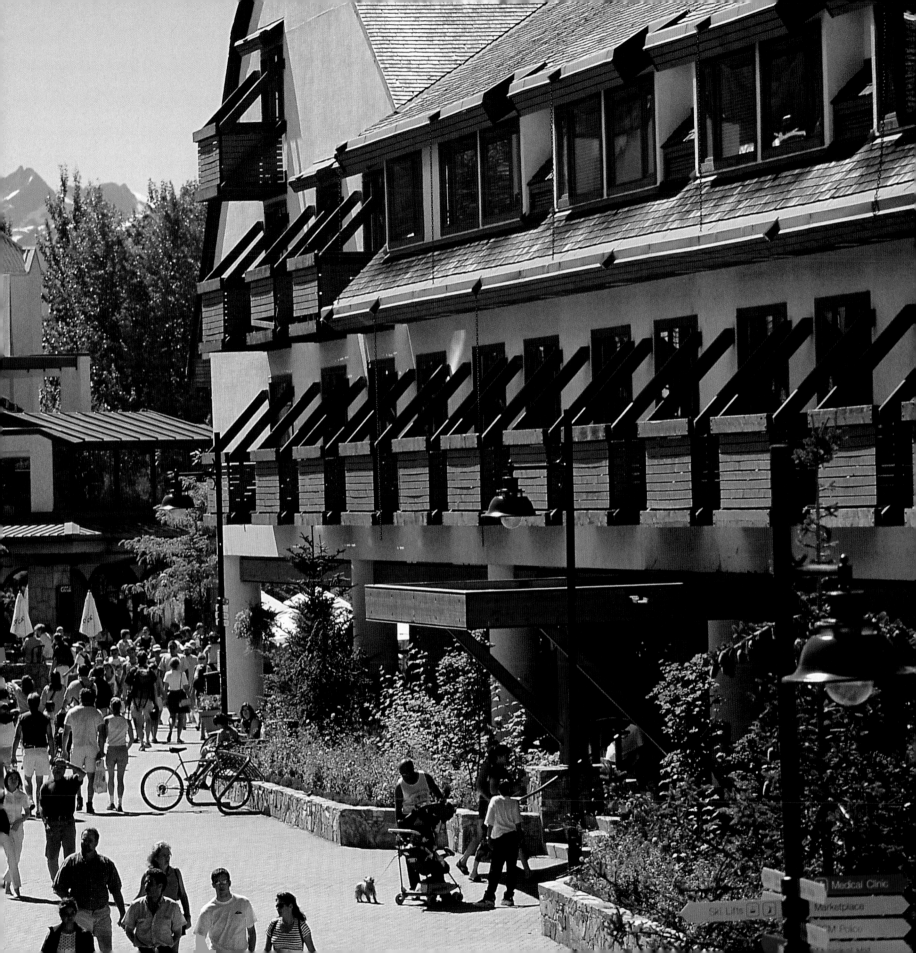

Street entertainers like this juggler, along with high profile acts and outdoor concerts, are organized by the Whistler Resort Association to help make the village as enjoyable in summer as it is during the ski season.

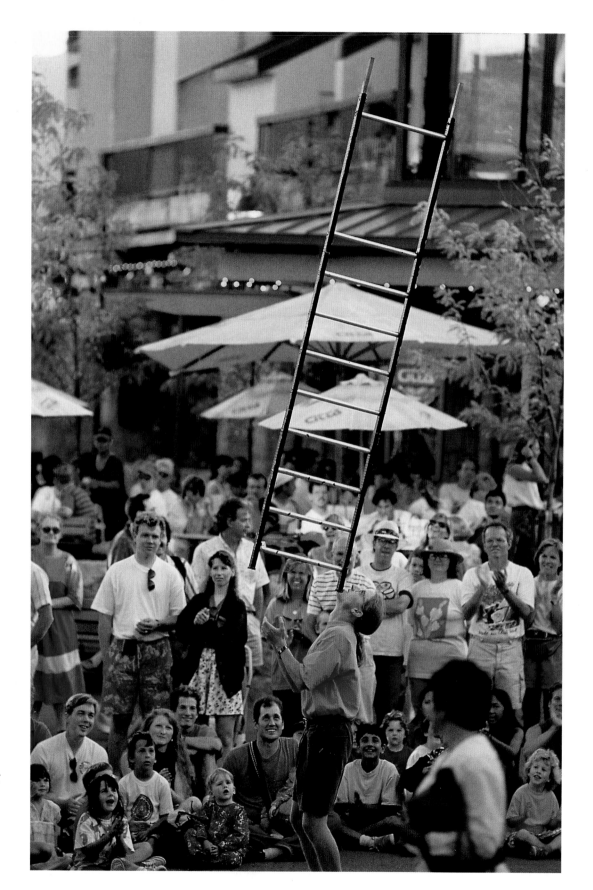

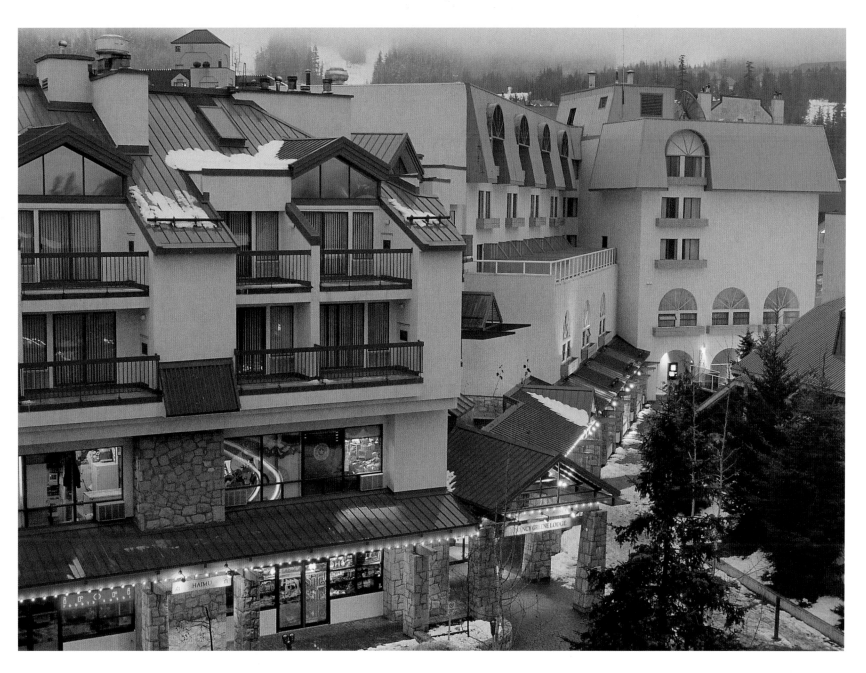

Nancy Greene Lodge was built by Nancy Greene Raine, Canada's Olympic medal winner and world cup champion, and her husband, Al Raine. Both were prominent figures in the early development and promotion of Whistler.

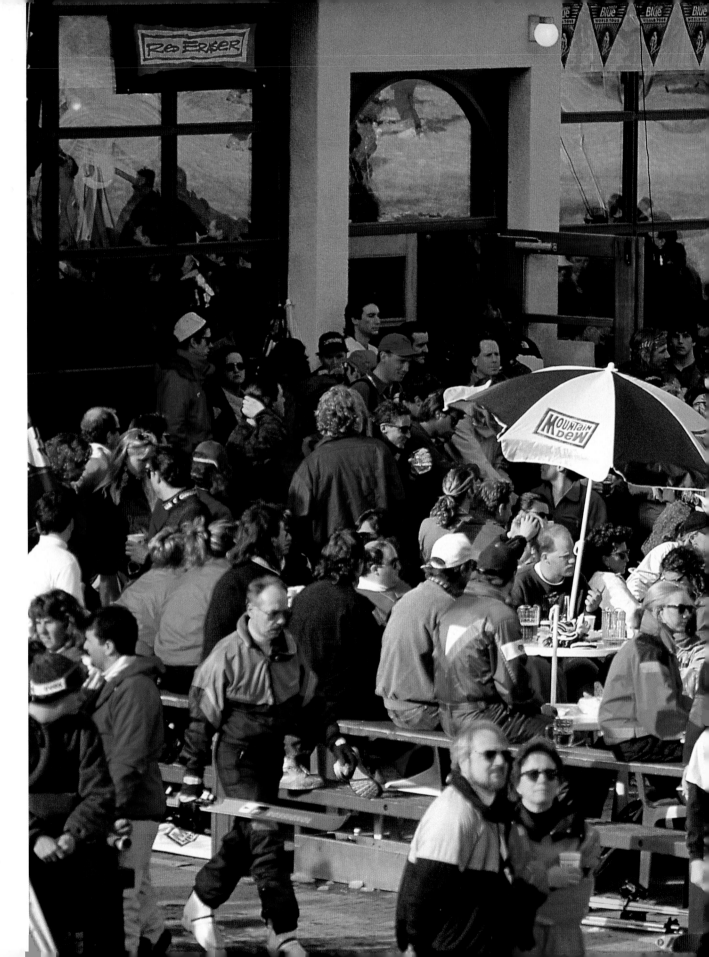

The après-ski crowd
keeps shops and
restaurants booming.

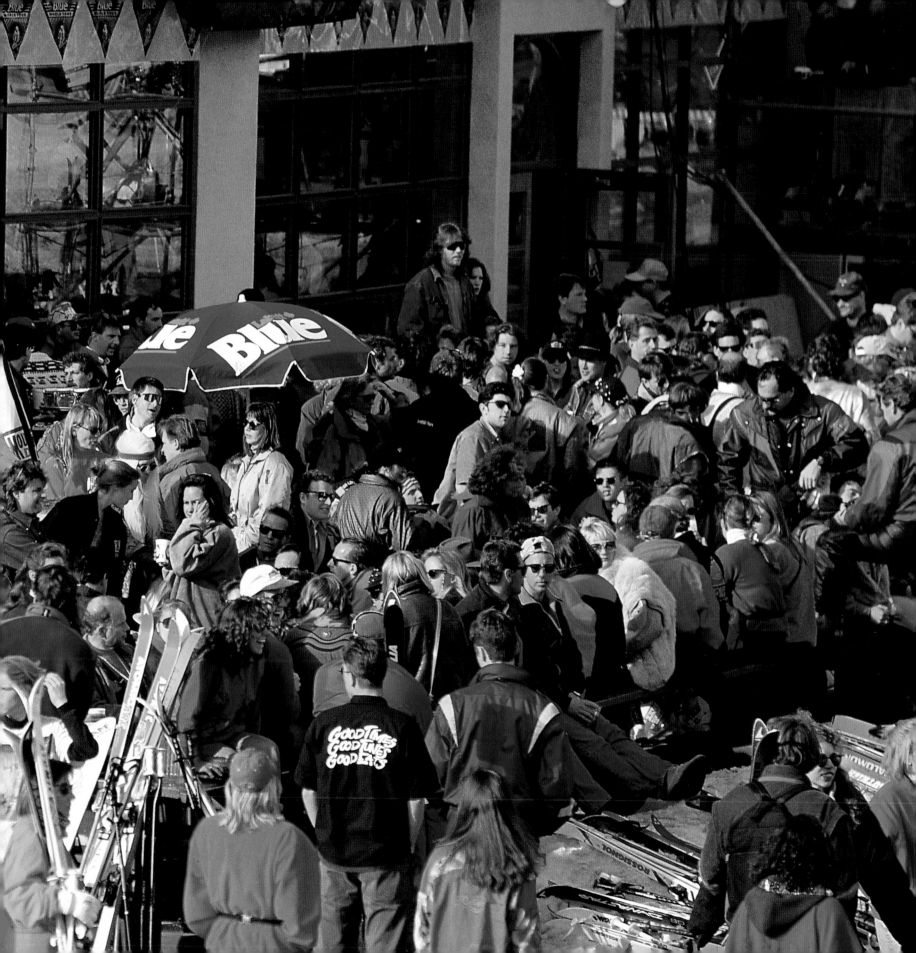

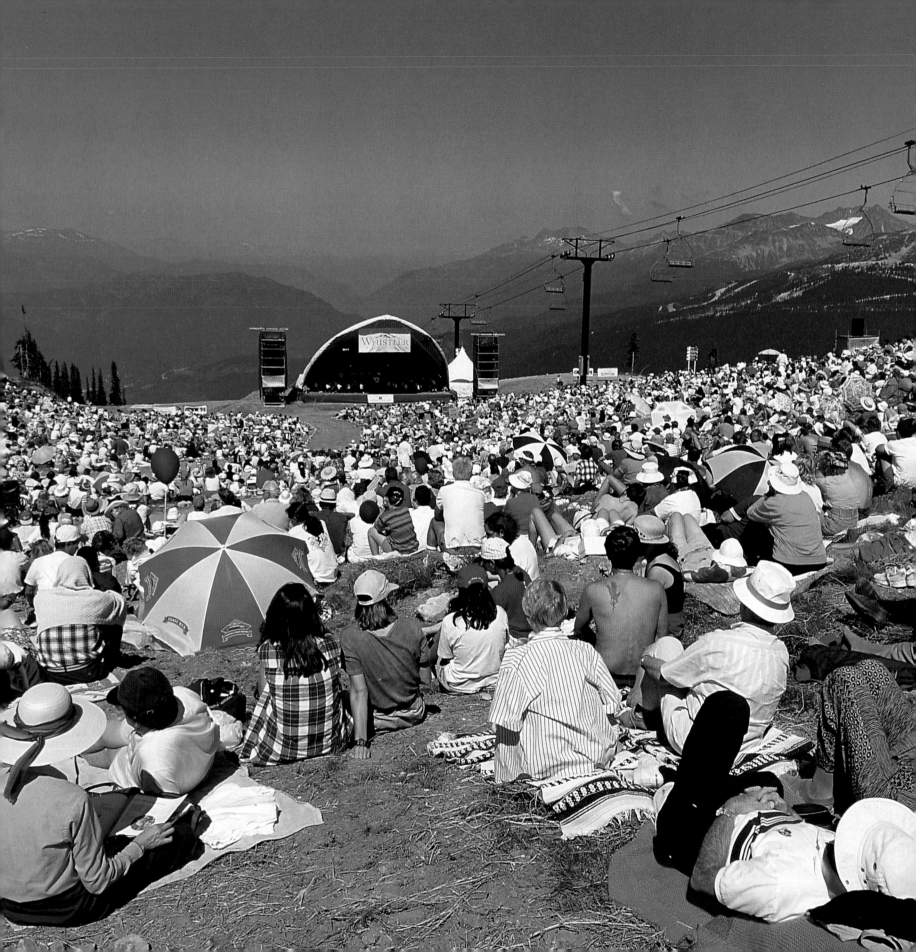

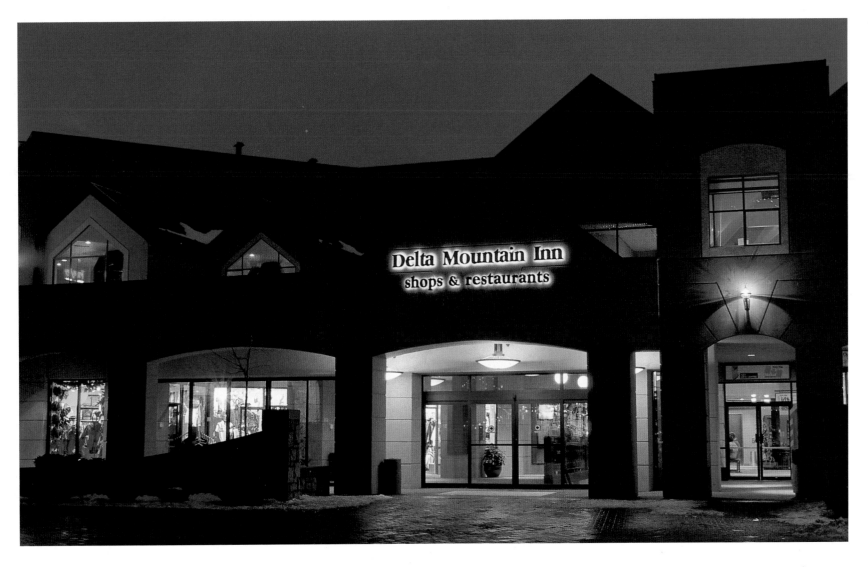

The Delta Mountain Inn is just moments away from the lifts of both Whistler and Blackcomb mountains.

The Rankin Family, Colin James, and children's favourite Fred Penner are among the musical guests who have delighted concert goers on Whistler Mountain.

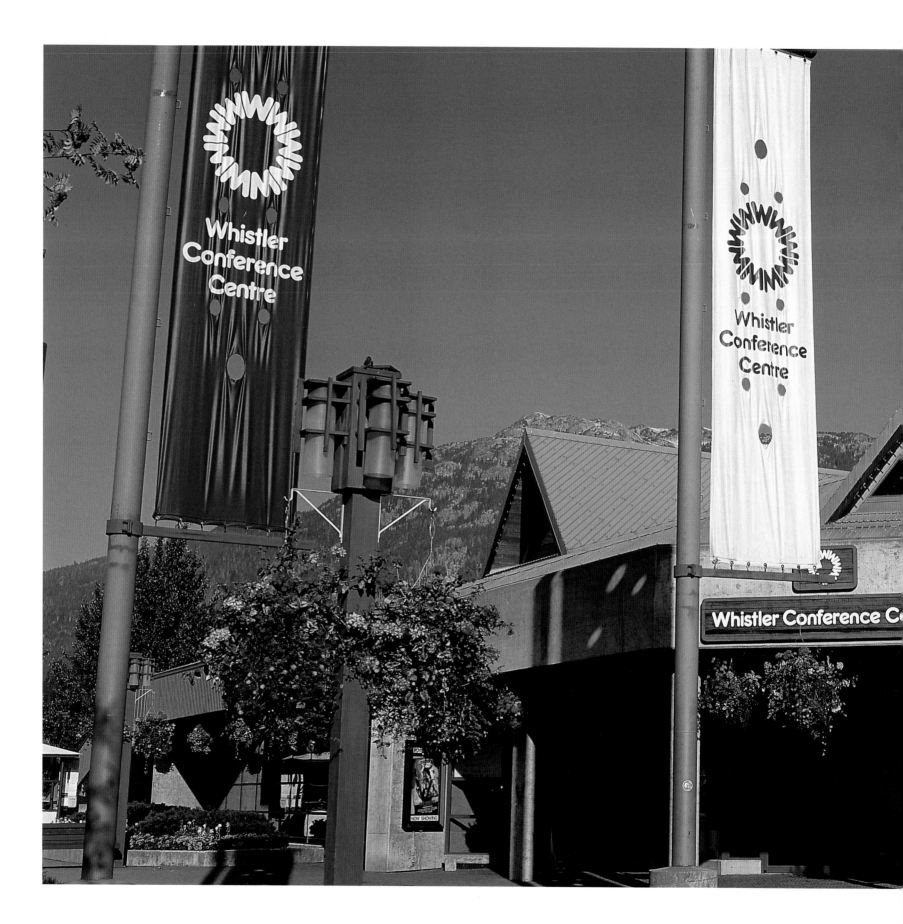

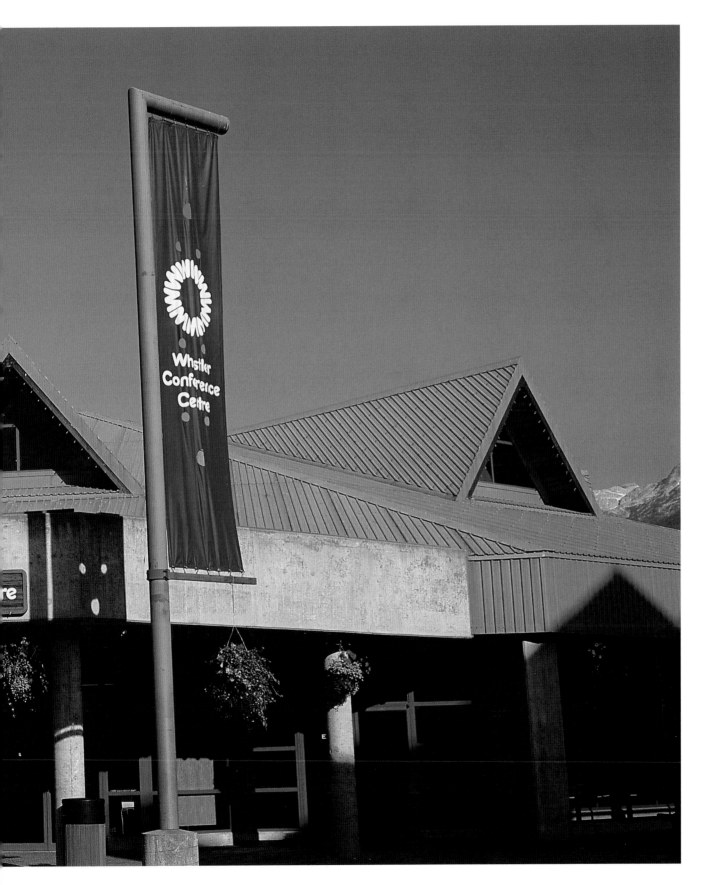

With a ballroom,
a theatre, an atrium,
a patio, and nine
conference rooms,
the conference
centre can host
1600 people.

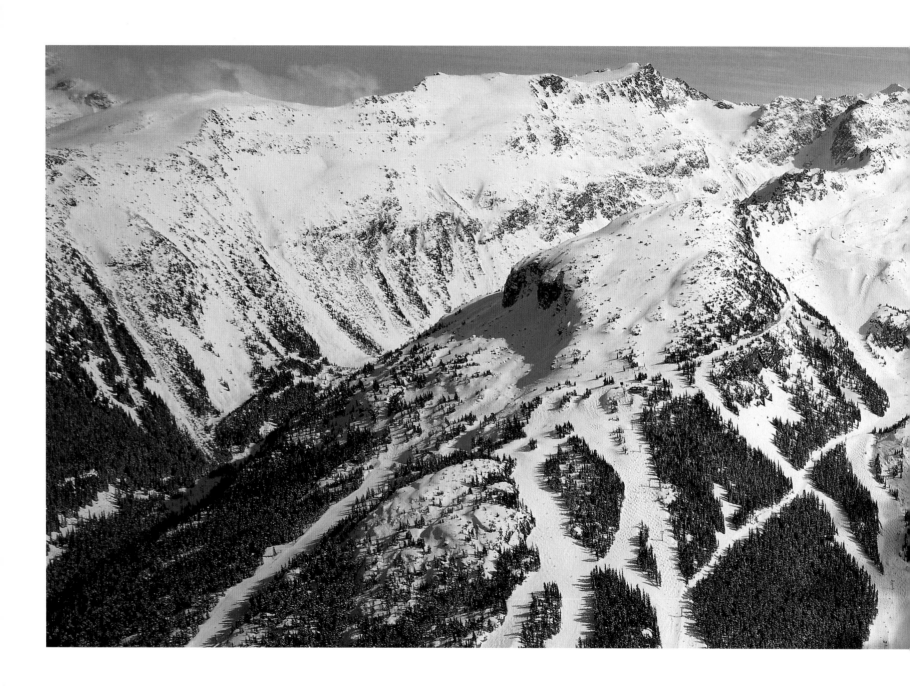

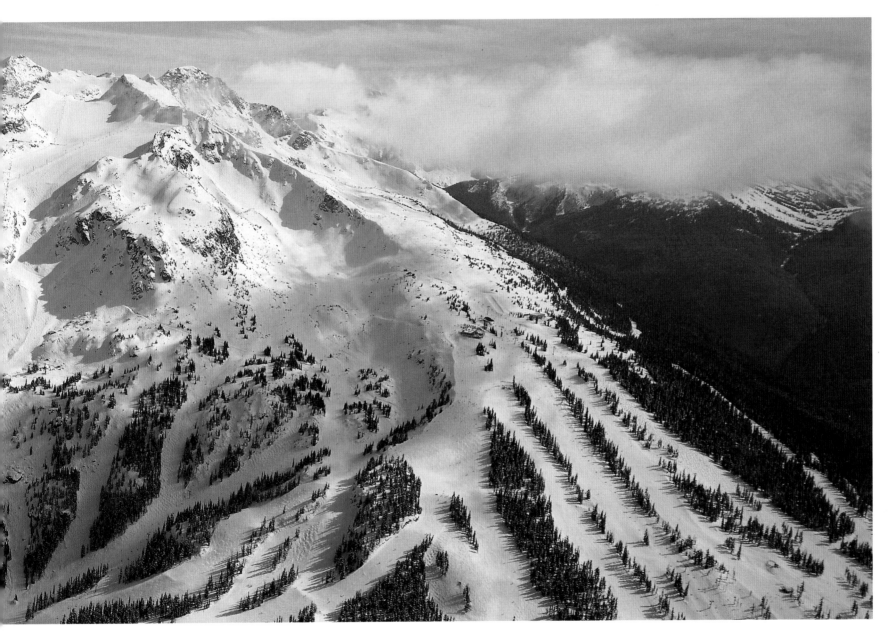

Together, Whistler and Blackcomb offer more than 30 lifts and 200 ski runs. The longest runs stretch for 11 kilometres.

Nine hundred instructors help make the Whistler/
Blackcomb Ski and Snowboard School the largest in
Canada. Many kids get their start at Blackcomb's Kids
Kamp or Whistler's Ski Scamps.

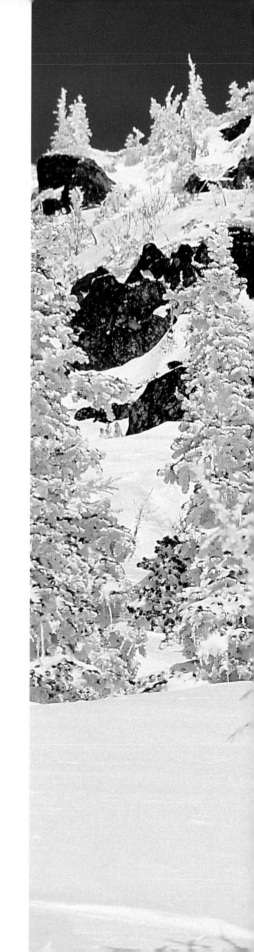

High on the peaks, alpine bowls such as Symphony
Bowl become winter reservoirs of powder.

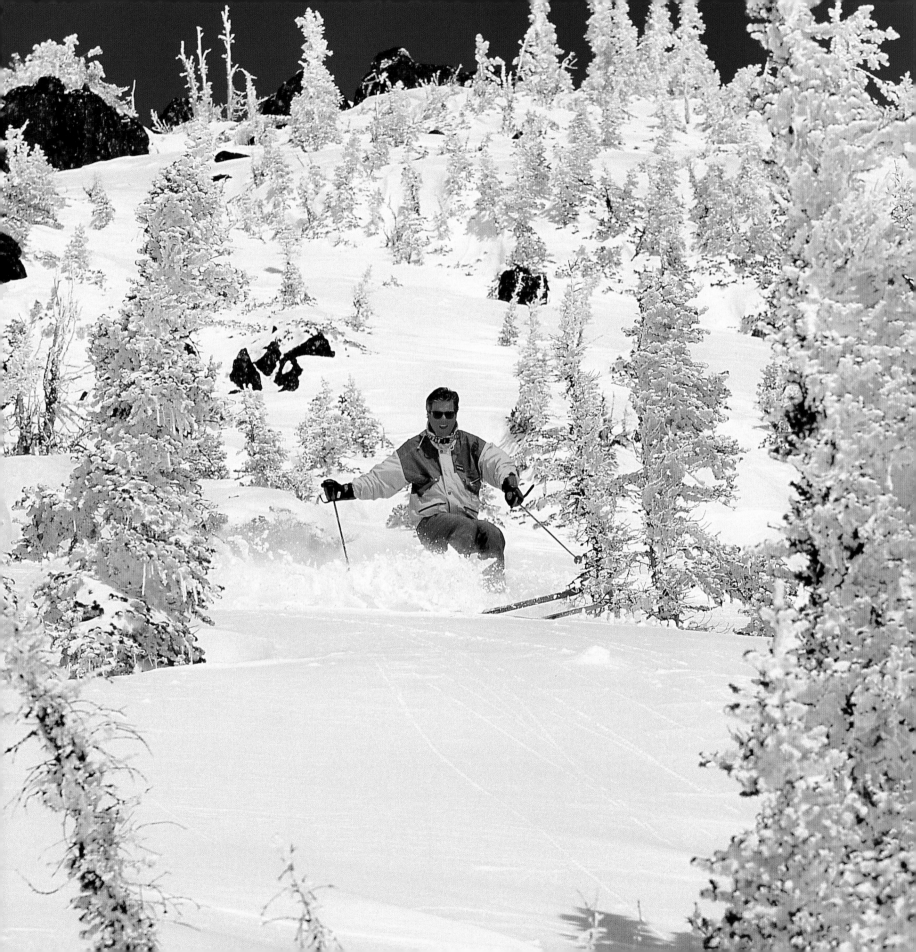

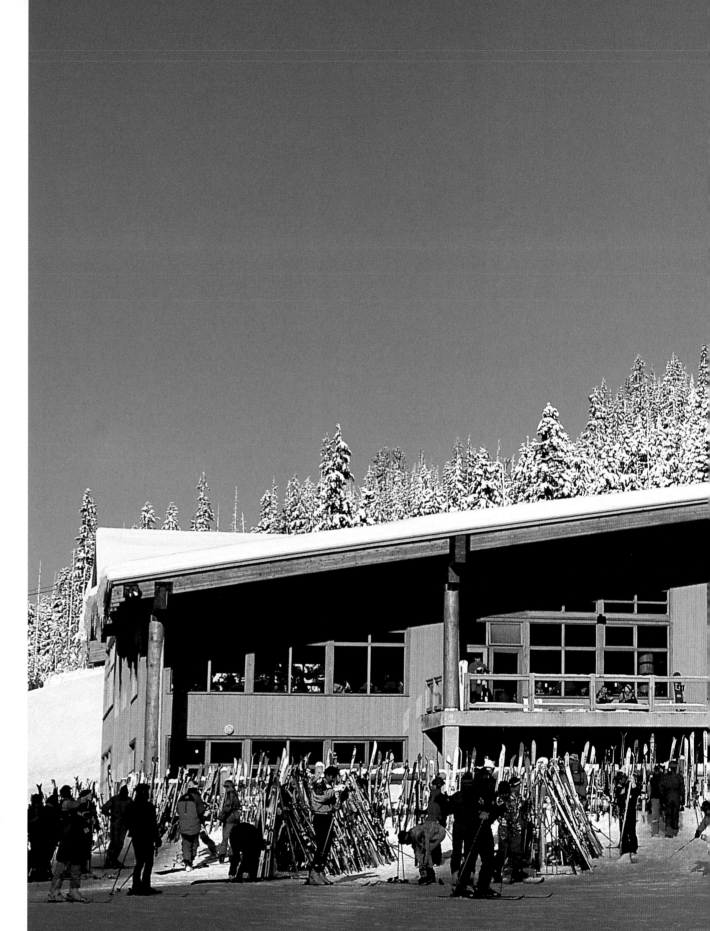

Glacier Creek Lodge offers a place to rest knees and enjoy a warm drink part way up Blackcomb.

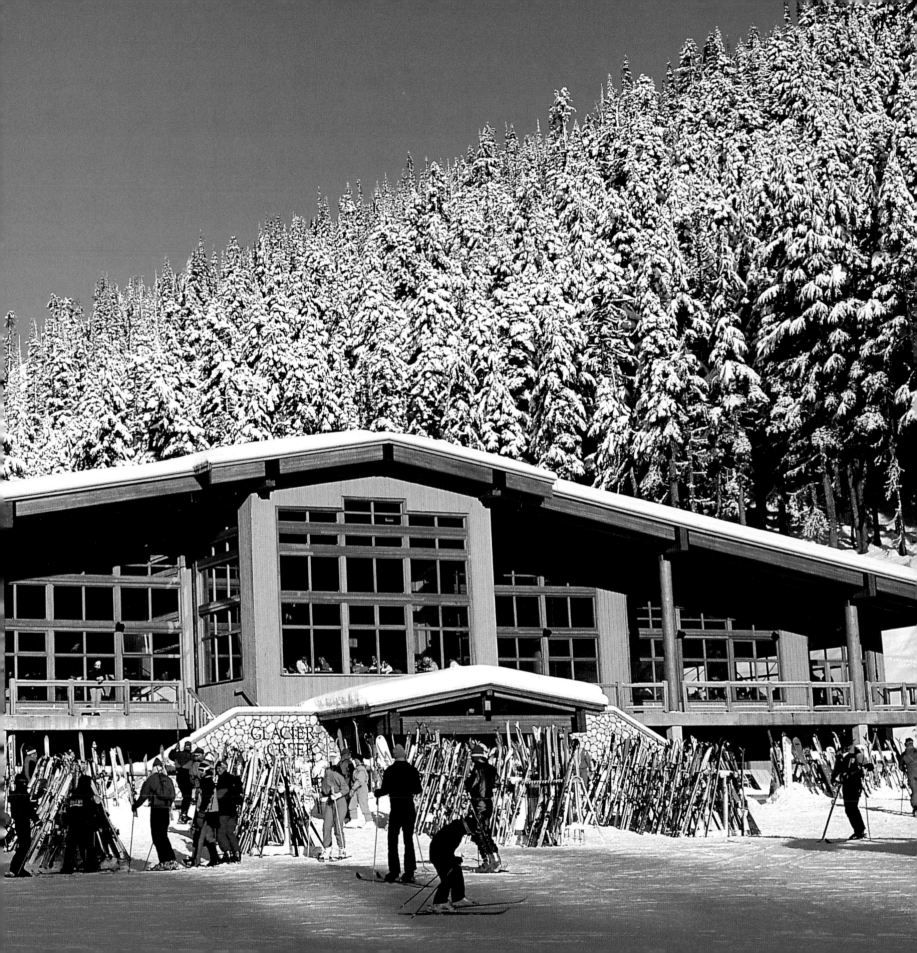

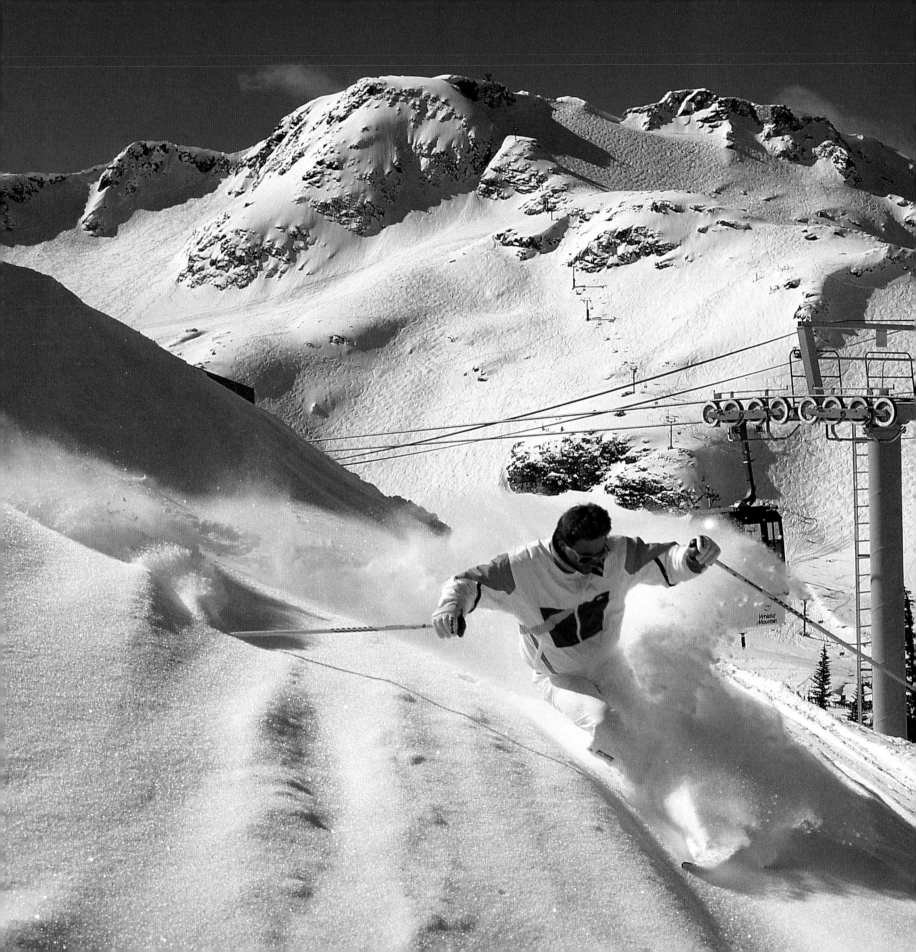

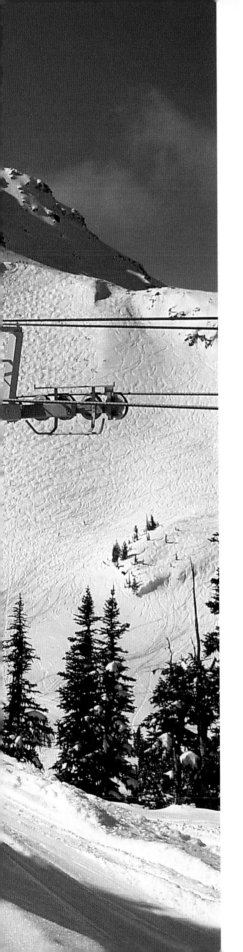

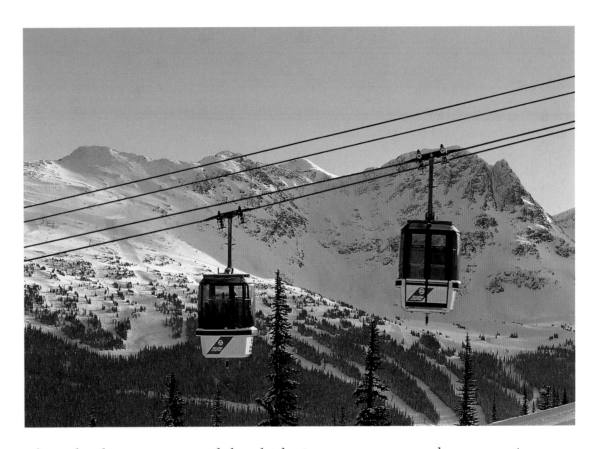

The Whistler express gondola whisks its passengers up the mountain.

High-profile skiers to visit the resort have included
Pierre Trudeau, Prince Charles and his sons William
and Harry, and countless Hollywood stars.

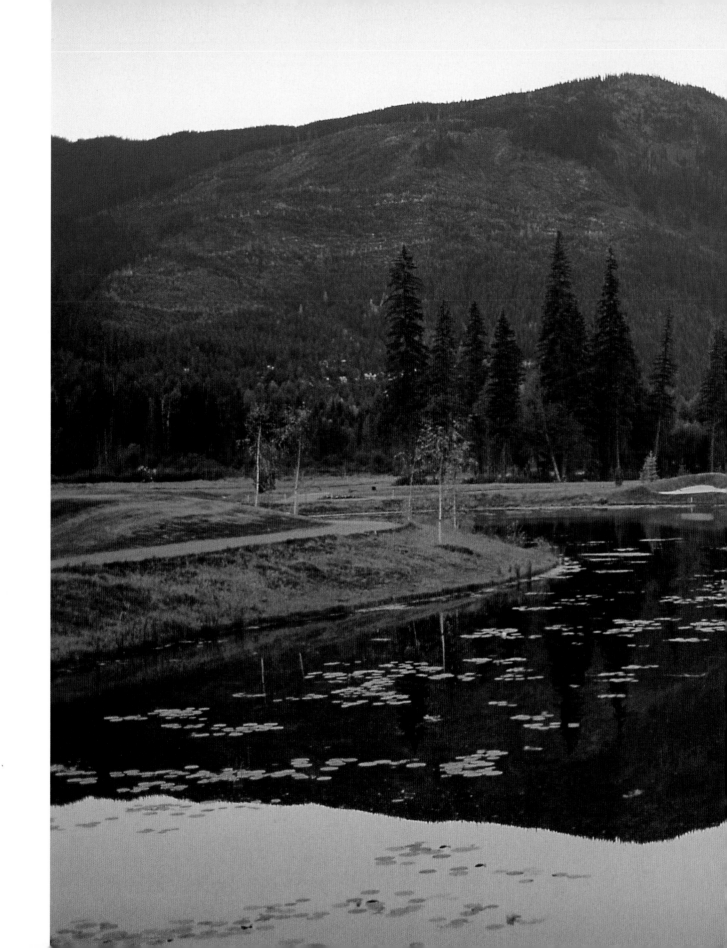

Golf Digest named Nicklaus North Golf Course the best new course in Canada after it opened in 1995.

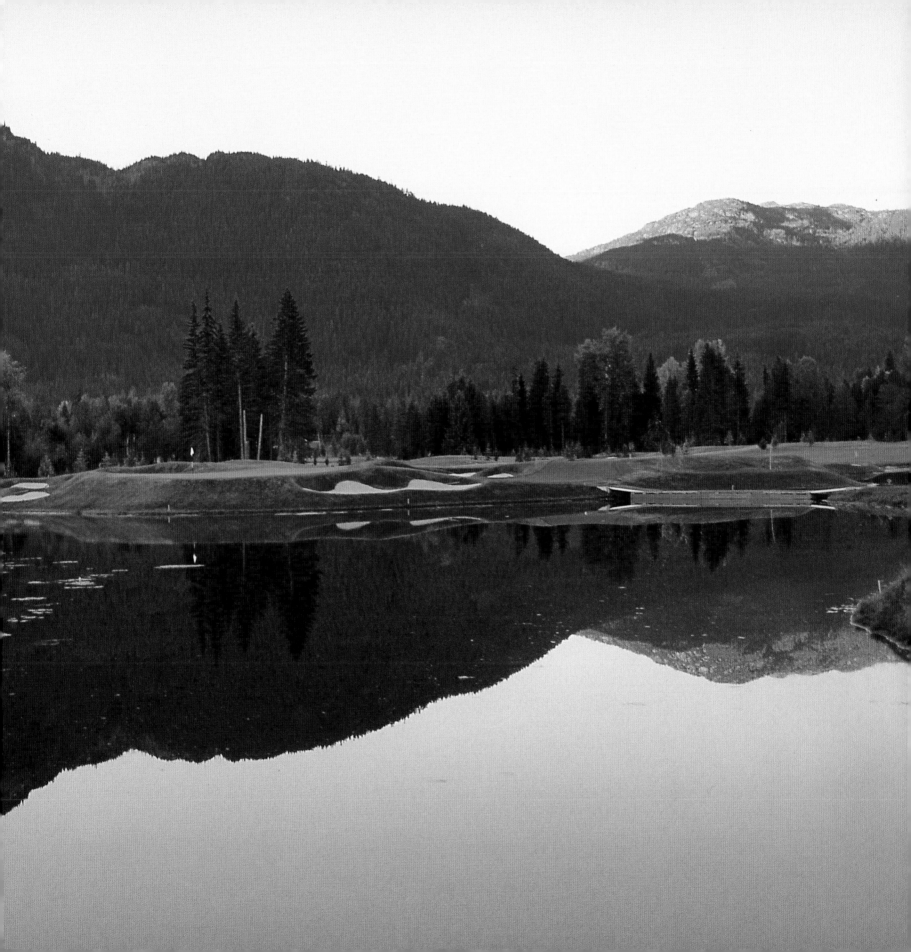

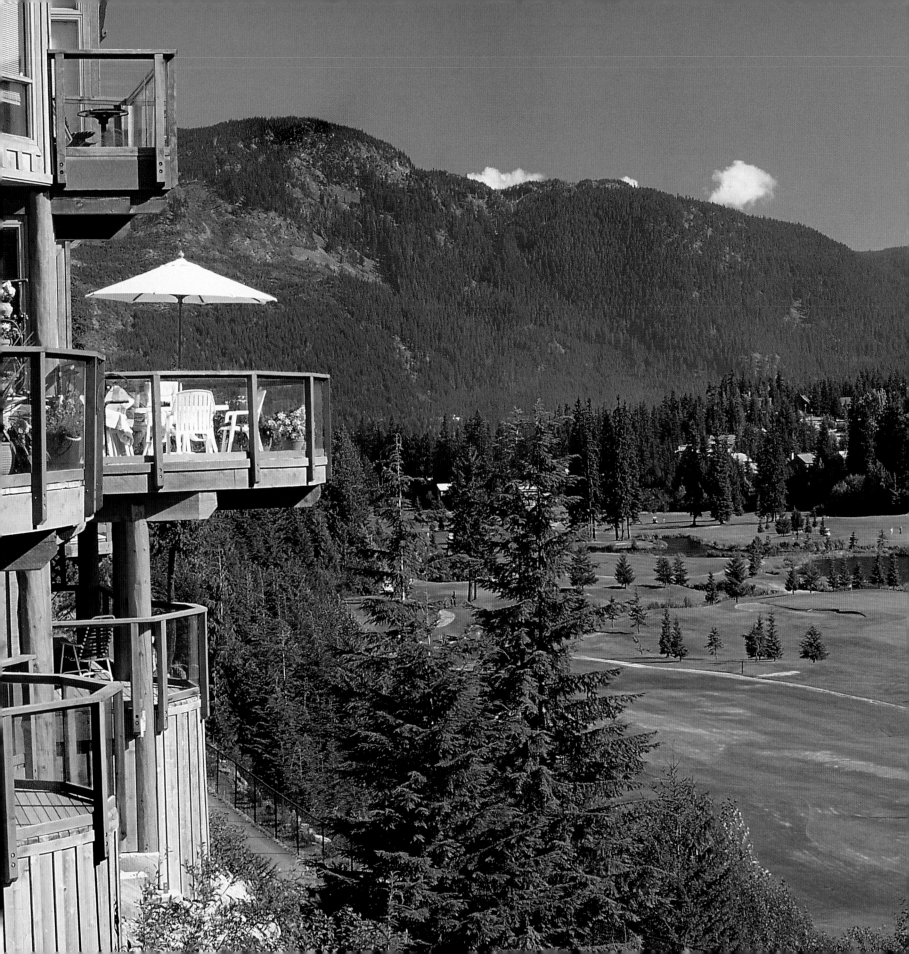

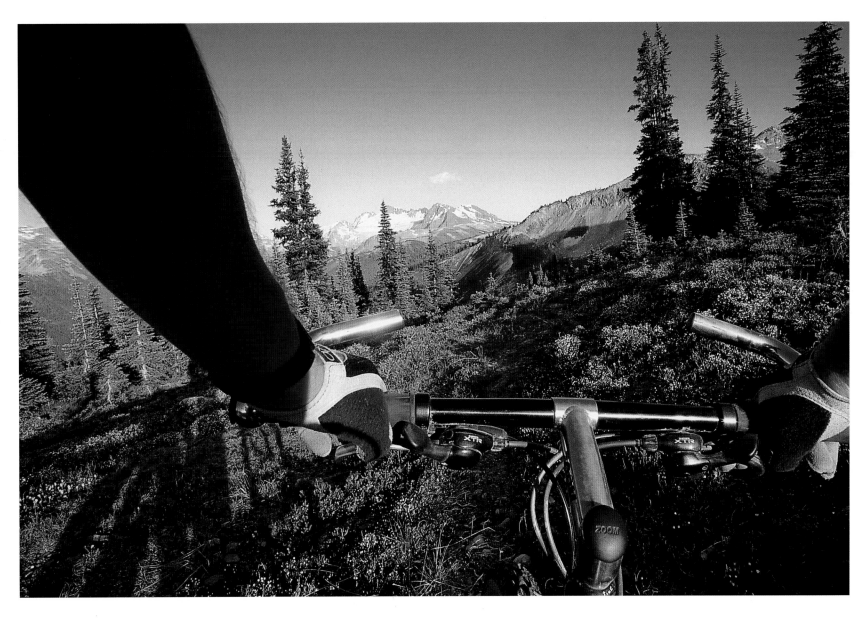

Cyclists can choose to tear down to the valley from the top of the lifts, or enjoy a more sedate route along twenty kilometres of paved valley trails.

Designed by Arnold Palmer in 1982, Whistler Golf Club is the area's busiest course. Golfers play more than 20,000 rounds a year here.

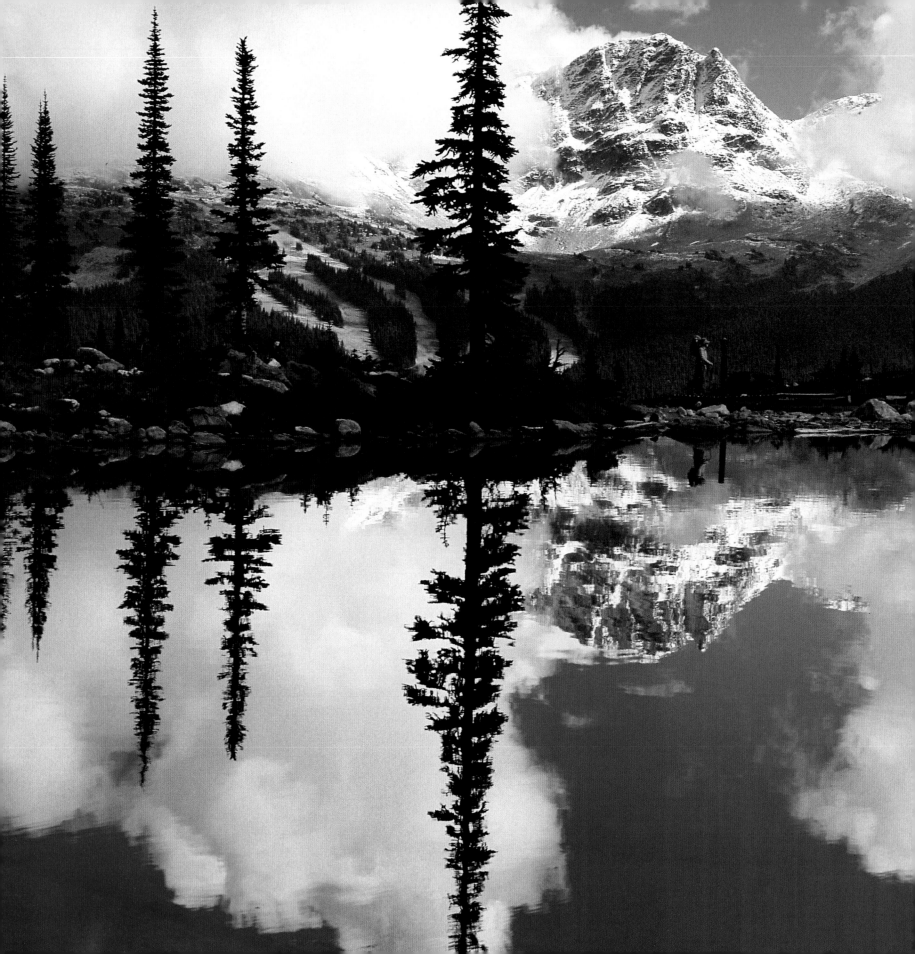

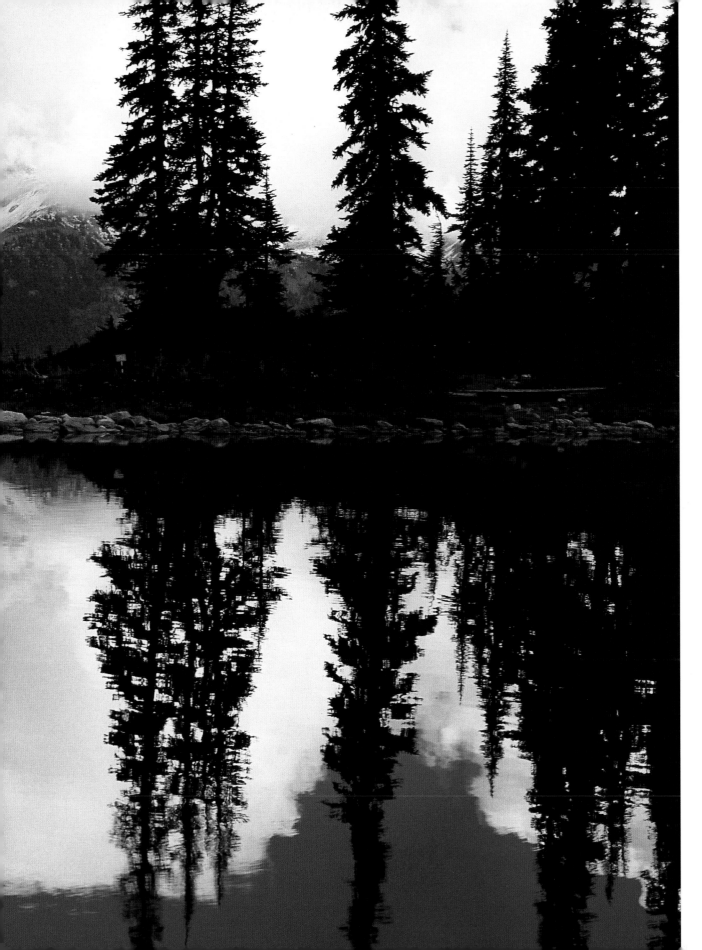

A 3.5-kilometre loop trail above the Village Express Gondola draws hikers to the shores of Harmony Lake. Blackcomb peak is reflected in its waters.

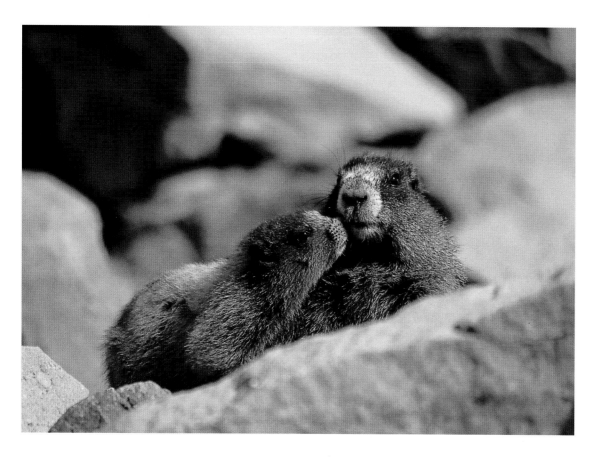

Whistler Mountain is named for the whistling call of the western hoary marmot, a furry inhabitant of the alpine meadows.

Campers escape civilization at one of the area's isolated alpine lakes.

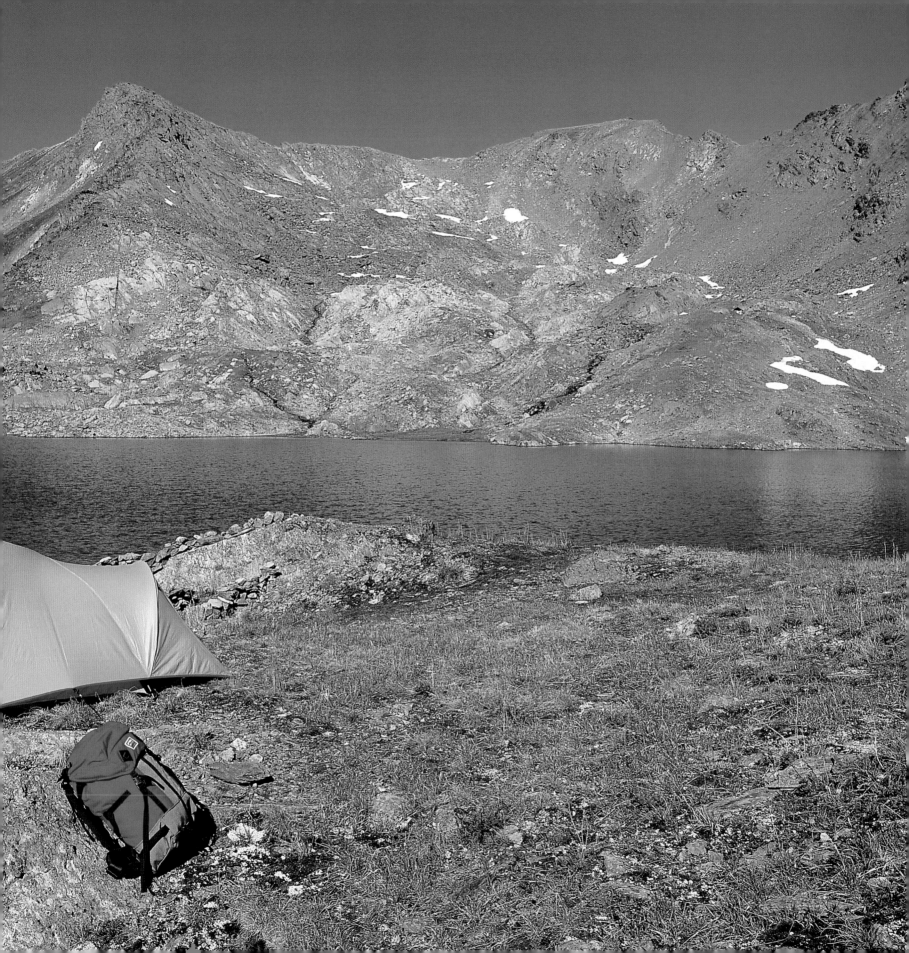

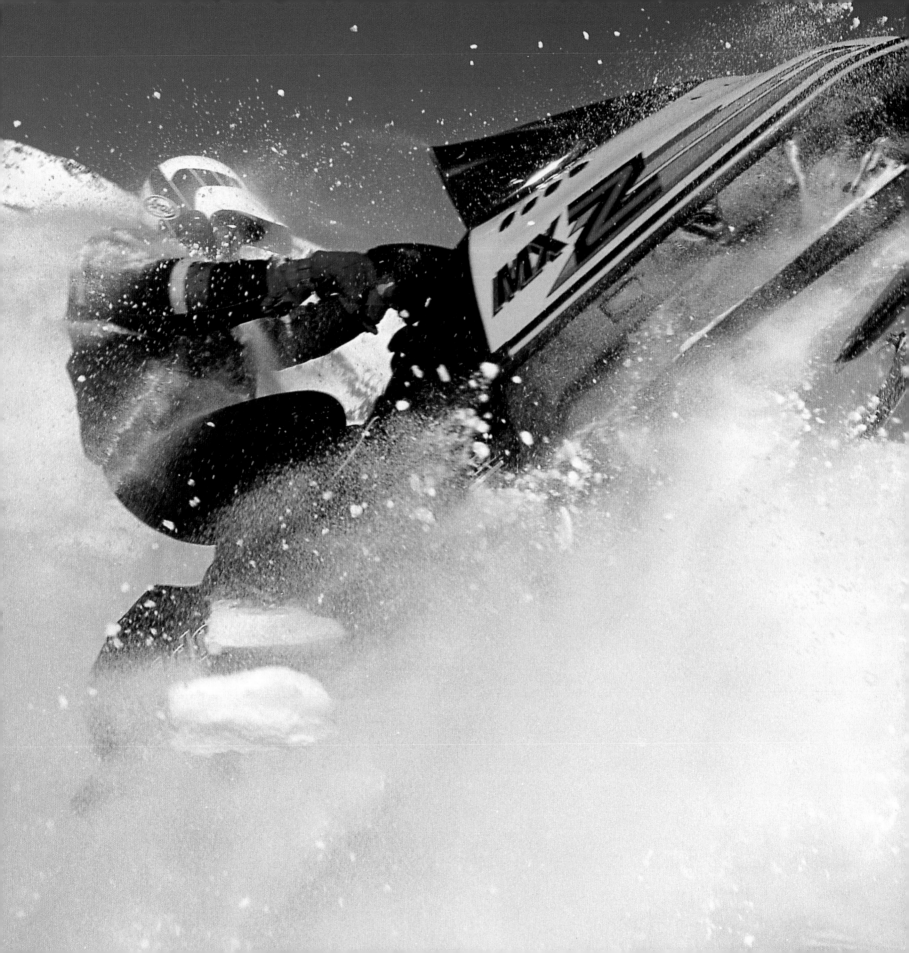

Heavy snowfall makes the area perfect for snowmobiling. One favourite winter trip is to a natural hot springs north of Pemberton.

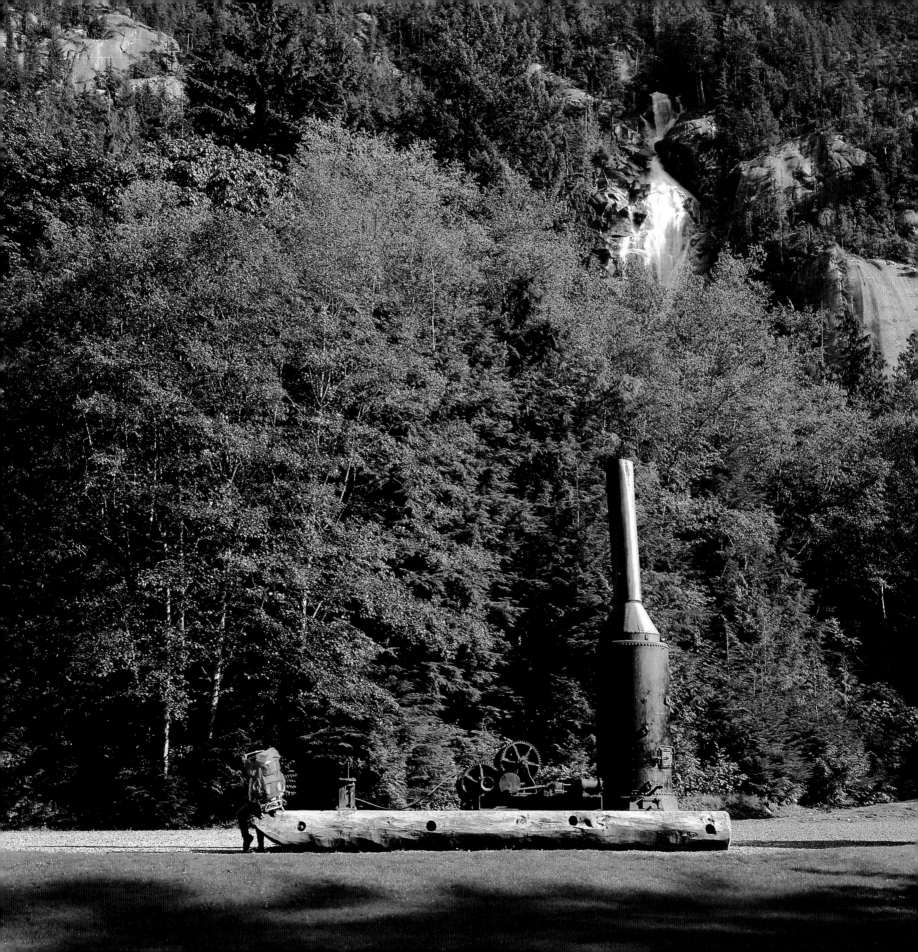

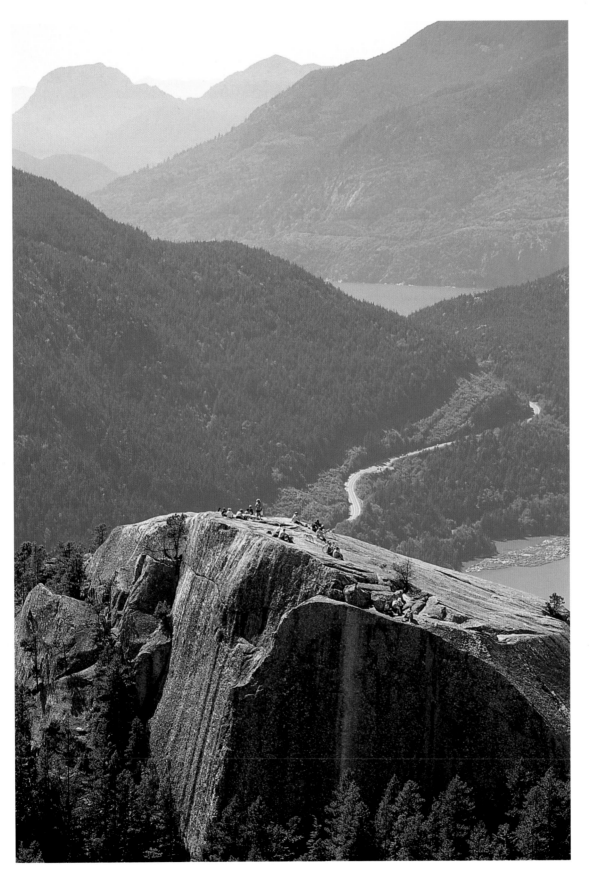

Stawamus Chief towers over Highway 99 on the route from Vancouver to Whistler. The Chief's 560-metre granite face draws rock climbers from across North America.

FACING PAGE— A donkey engine serves as a reminder of the hand logging done on Howe Sound in the early part of the century. Above, Shannon Falls drop a spectacular 335 metres.

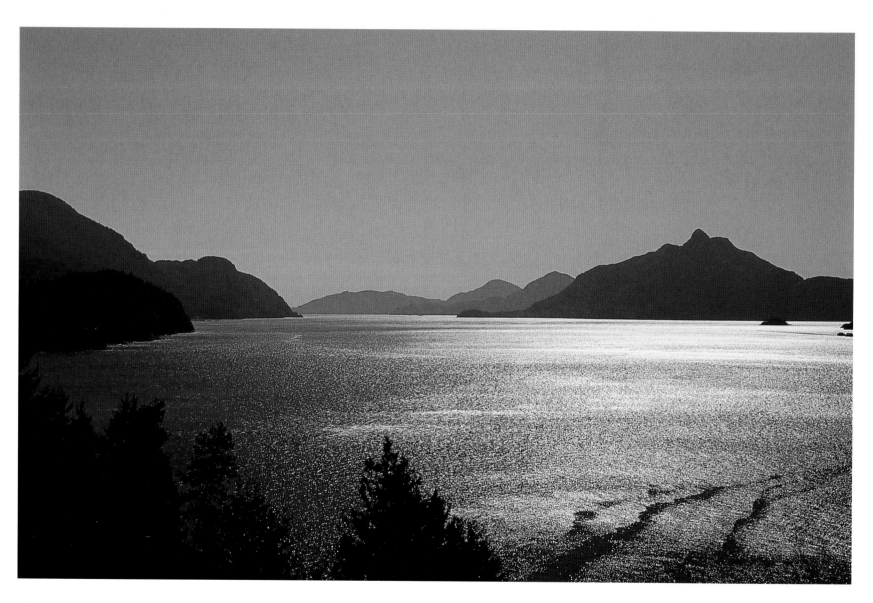

The drive from Vancouver to Whistler gives visitors a panoramic view of Howe Sound.

About eighty percent of the world's heliskiing takes place in British Columbia. The sport offers the unique opportunity to enjoy spectacular snow conditions year-round on the peaks and glaciers surrounding Whistler.

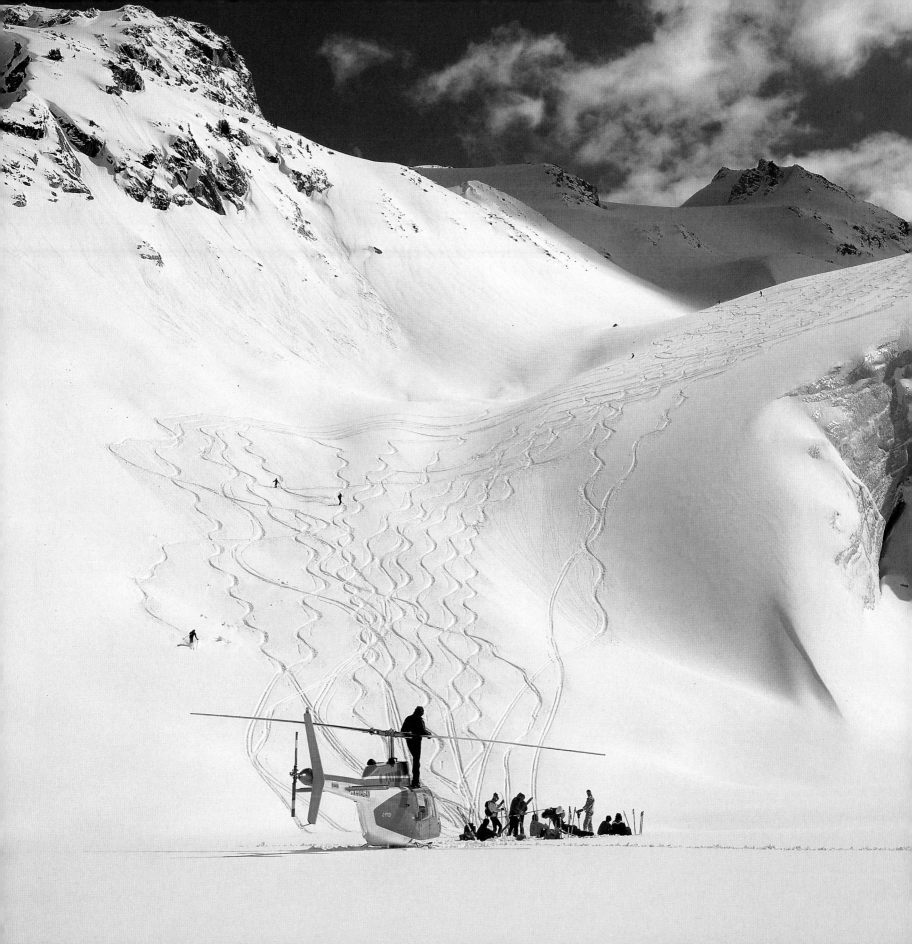

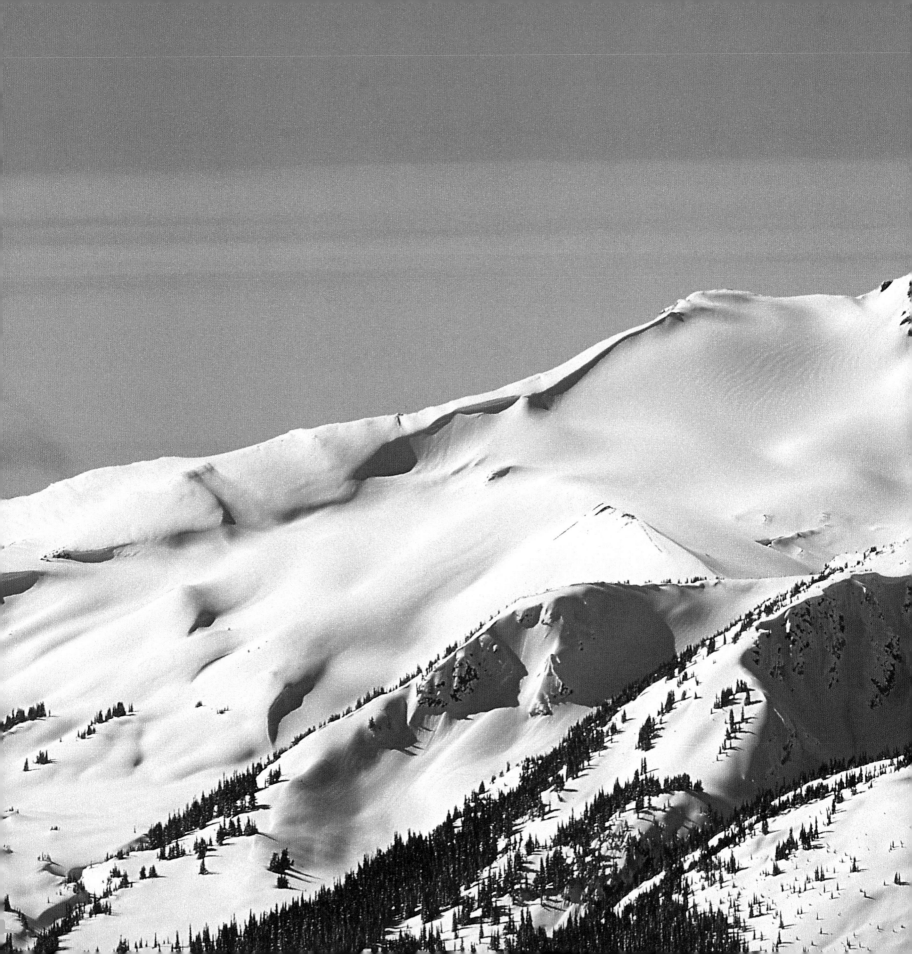

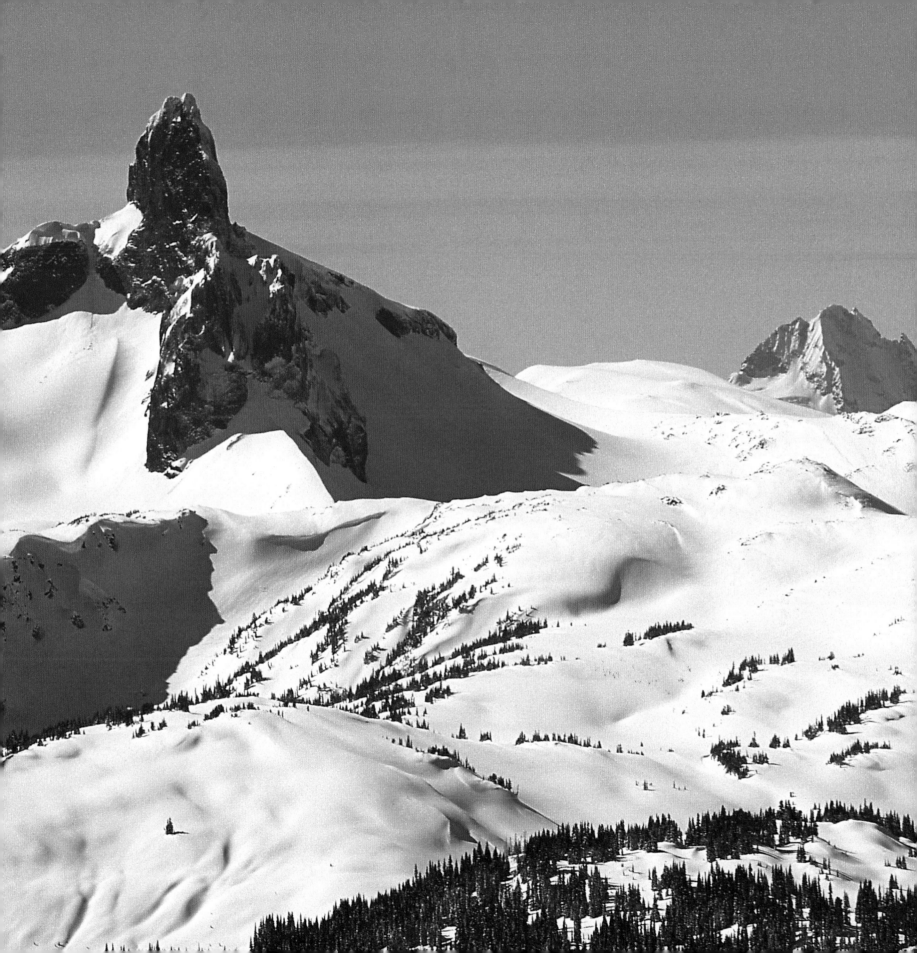

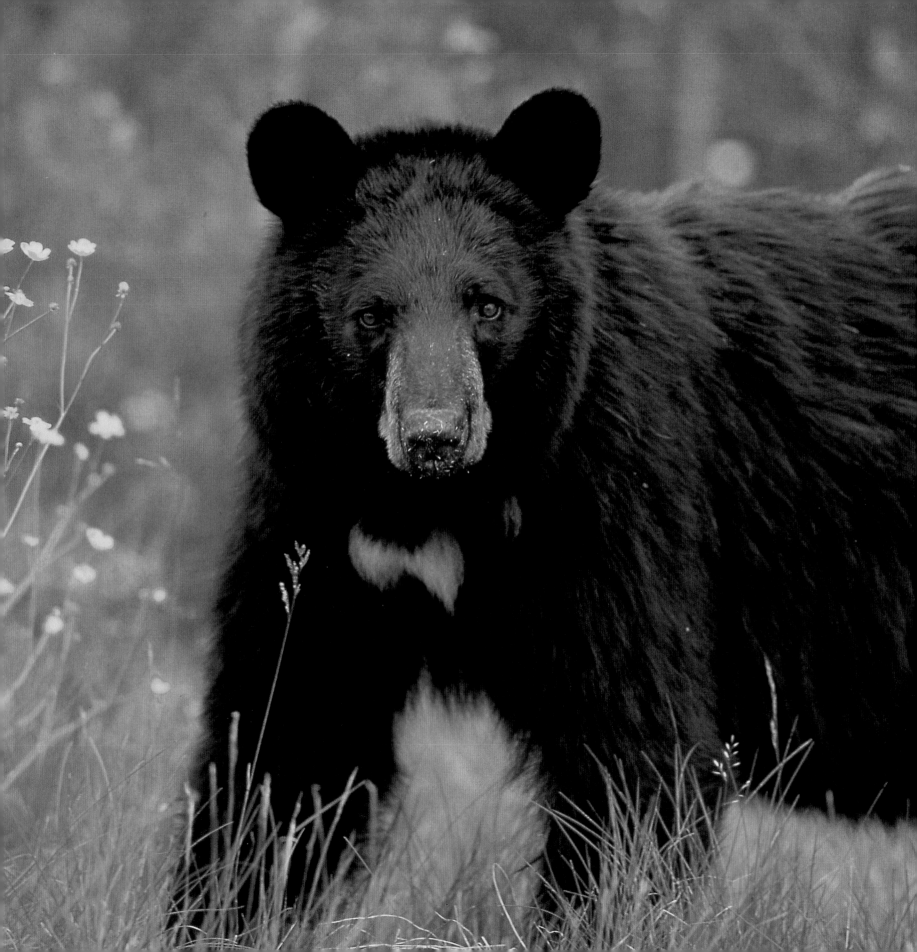

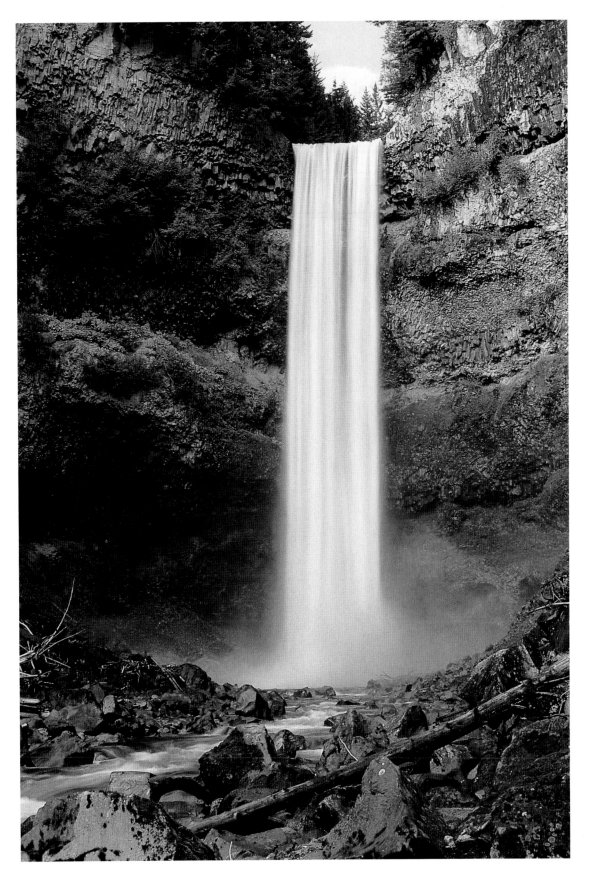

Brandywine Falls earned its name when surveyors Bob Mollison and Jack Nelson bet a bottle of brandy against one of wine over the height of the falls— 66 metres.

FACING PAGE— Black bears cover a large territory, sometimes roaming from the alpine to the seashore in the space of a season.

PREVIOUS PAGE— According to First Nations legend, Black Tusk is home to the Thunderbird, who creates thunder and lightning from the peak. This lava plug tops an extinct volcano, and reaches to 2,315 metres.

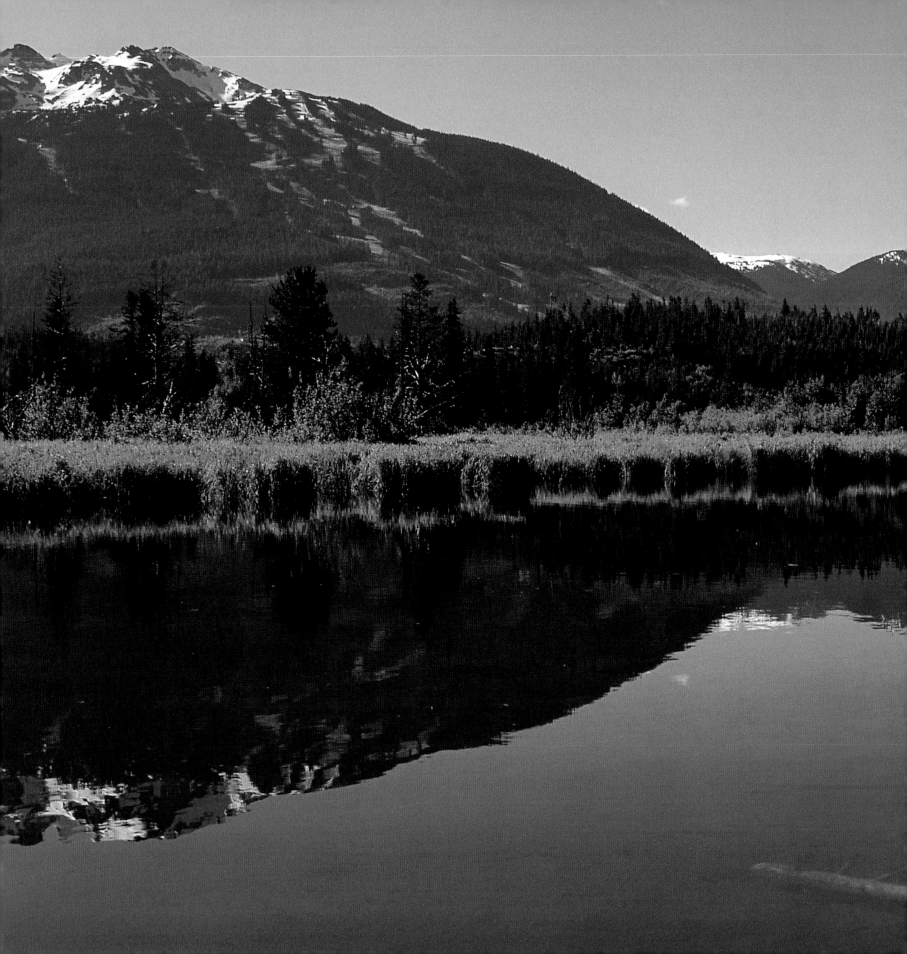

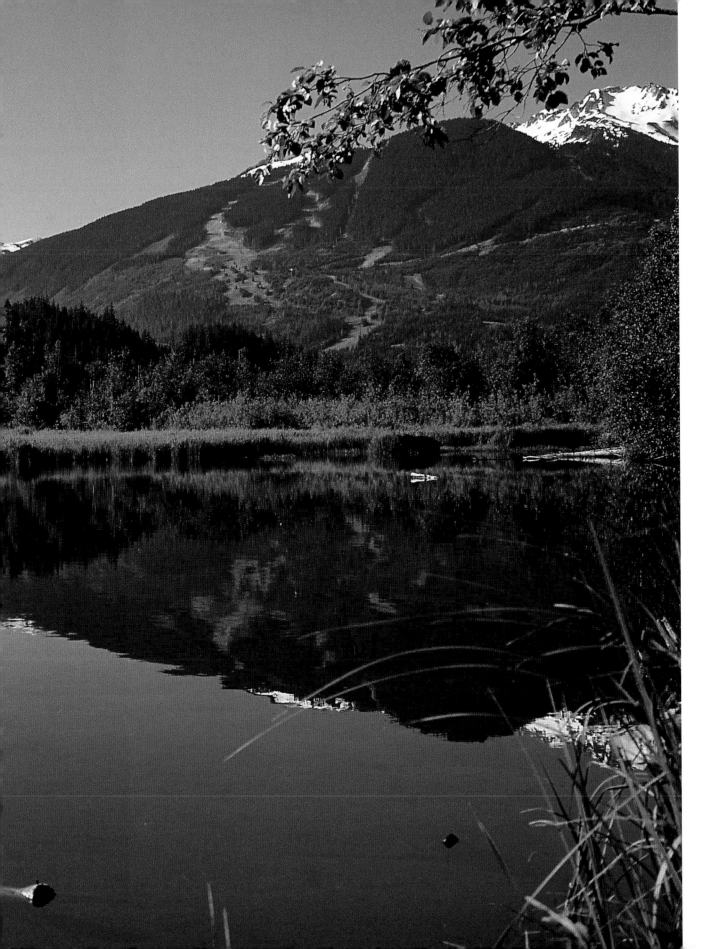

A tranquil beaver
pond reflects the
snow-capped peaks
of Blackcomb and
Whistler mountains.

59

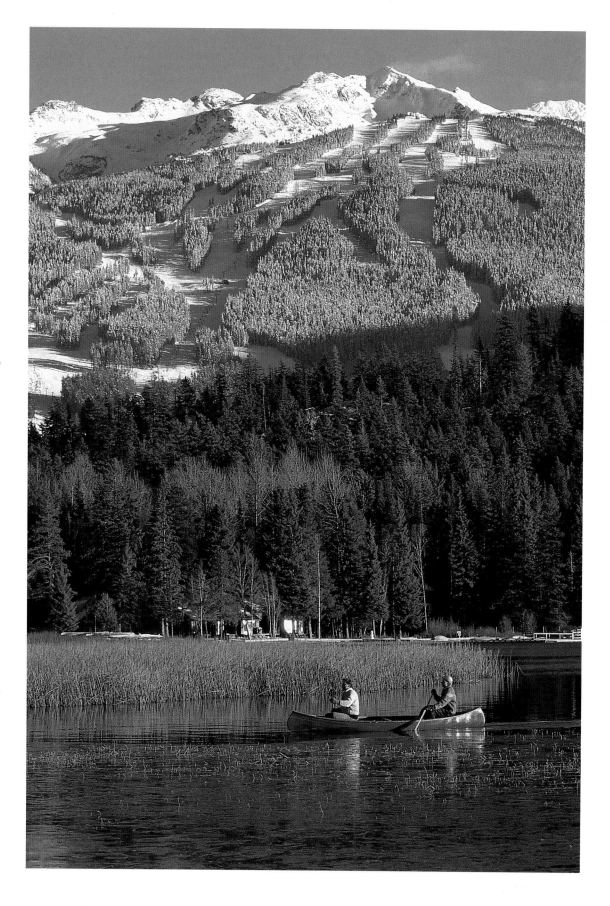

In the early 1900s, the route to Alta Lake involved a steamship, carts, and pack horses. Today, parks line the shores, paddlers enjoy the water, and in-line skaters glide by on the valley trails.

FACING PAGE—
Forests of western hemlock, birch, alder, cottonwood, Douglas fir, and western red cedar form a colourful tapestry in Garibaldi Provincial Park. Most of this 195,000-hectare park is accessible only to hikers and cross-country skiers.

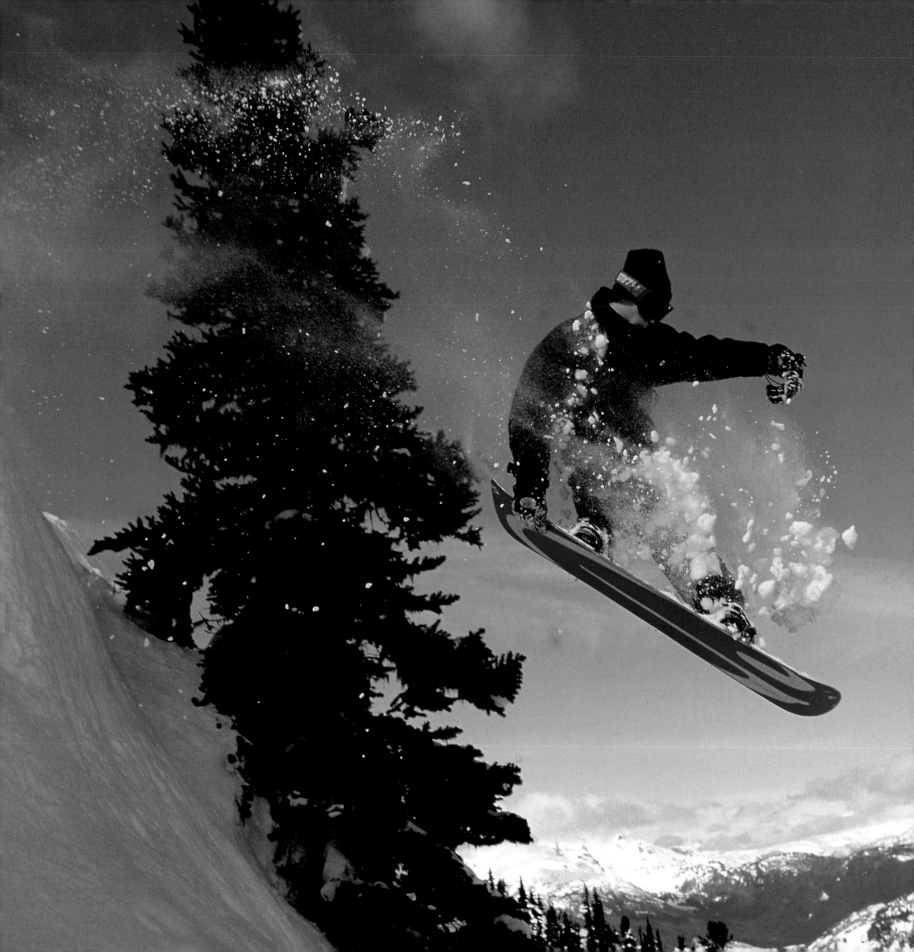

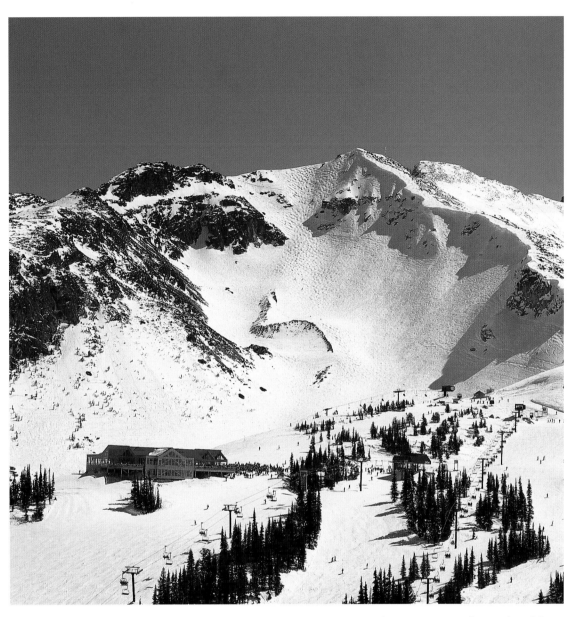

Breathtakingly steep, the Saudan Couloir was North America's first double black diamond run.

Traditionally, Whistler Mountain was the domain of skiers while snowboarders chose Blackcomb. With the booming popularity of snowboarding, however, boarders of all ages can now be found on both mountains.

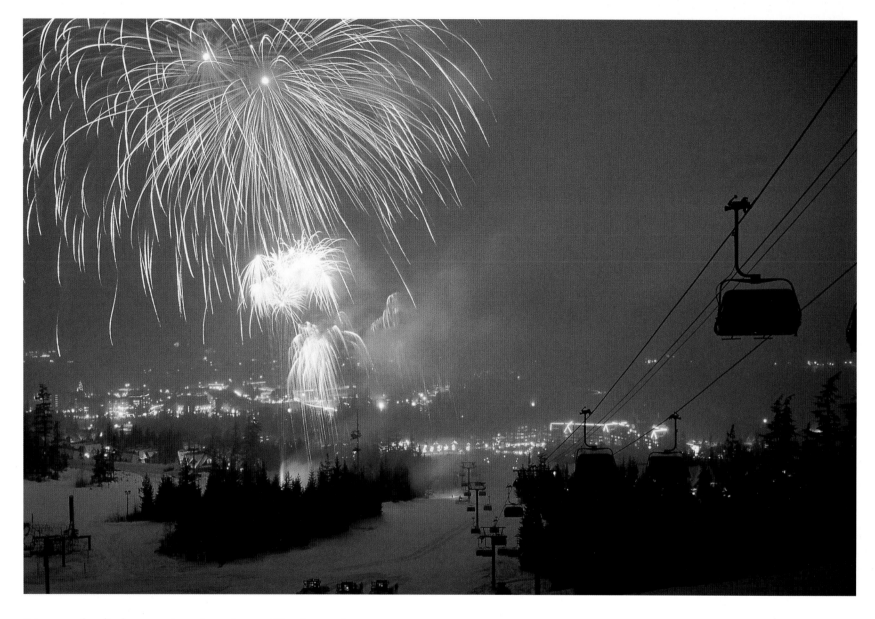

Fireworks light up the sky above Blackcomb.
One of Whistler's biggest celebrations is July 1,
when local organizations and businesses band
together to sponsor a parade and performances
in celebration of Canada Day.

On the slopes of
Blackcomb, fluores-
cent swathes are a
sign of paragliding
lessons in progress.
The lessons, which
run year-round,
offer visitors an
unmatched view of
the area.

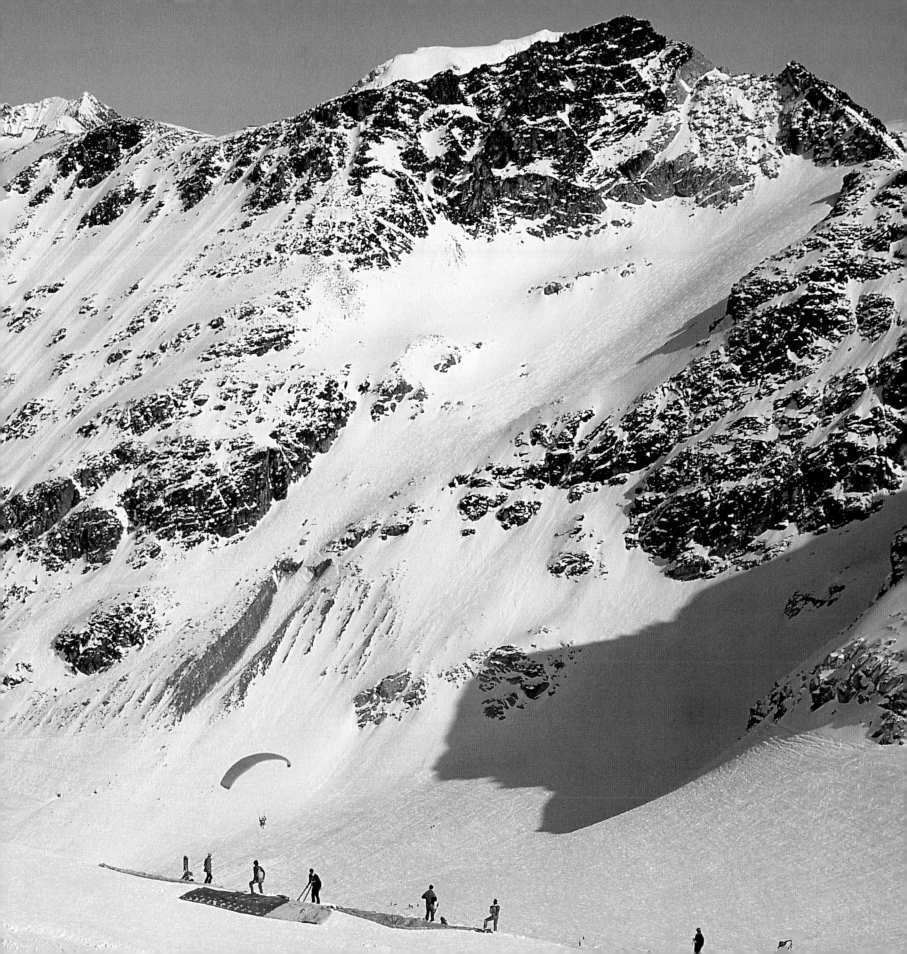

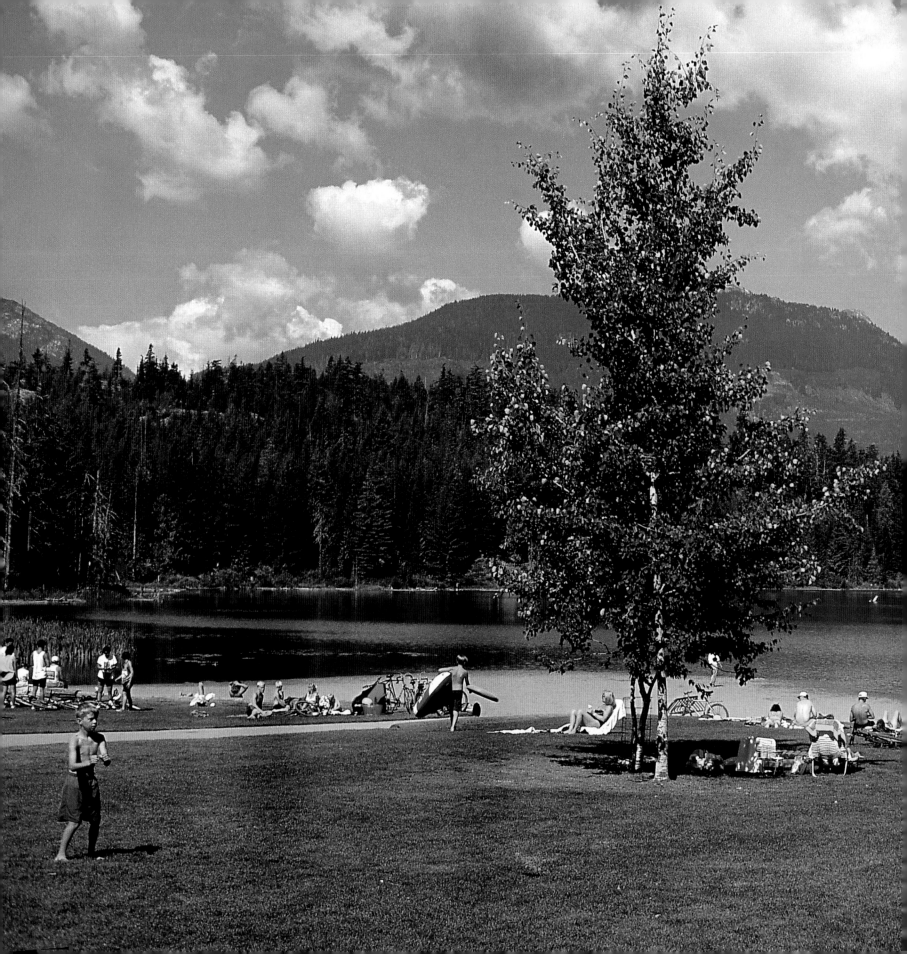

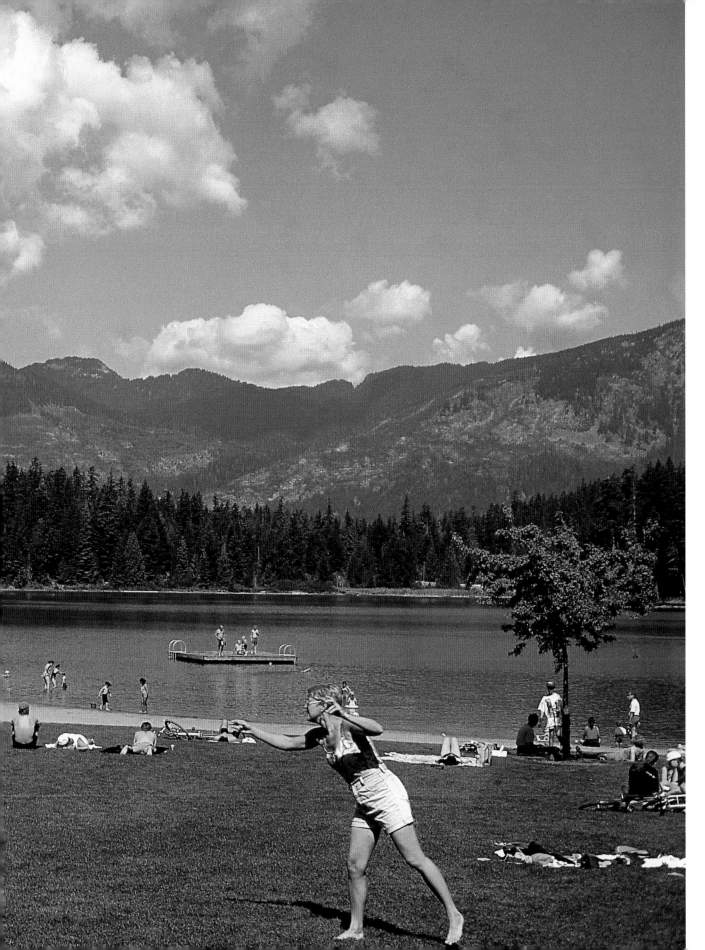

In the 1940s, a sawmill operated on the shores of Lost Lake, then part of a remote wilderness. Today, the lake is a favourite picnic spot, just a short bike ride from the village centre.

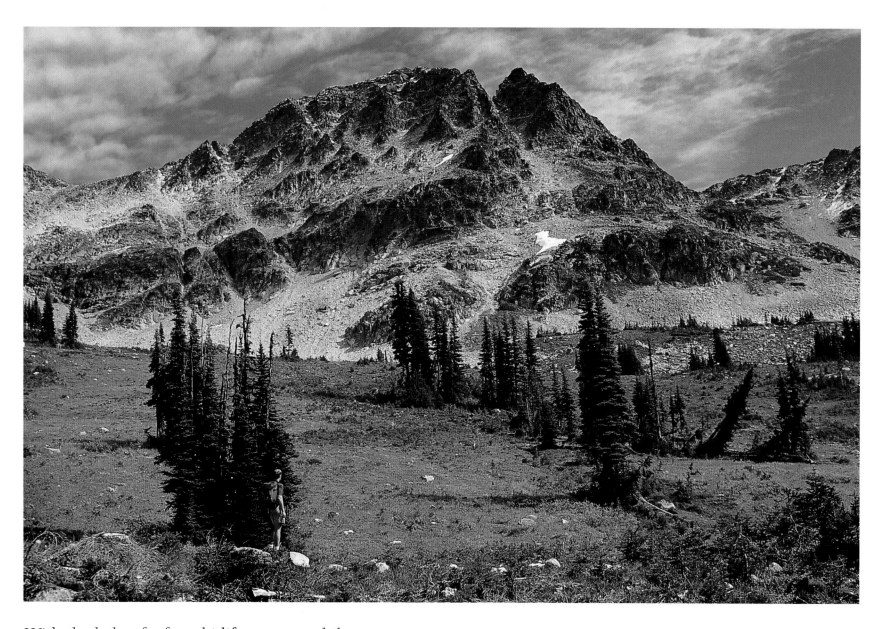

With the help of a few ski lifts, summer hikers can easily find themselves in alpine areas such as Xhiggy's Meadow, watching for deer, marmots, and wildflowers. The meadow was named for avalanche forecaster Peter Xhignesse.

In the early 1900s, a cabin on the shores of Green Lake was the home of early settler Charlie Chandler, who trapped throughout the area in the winters.

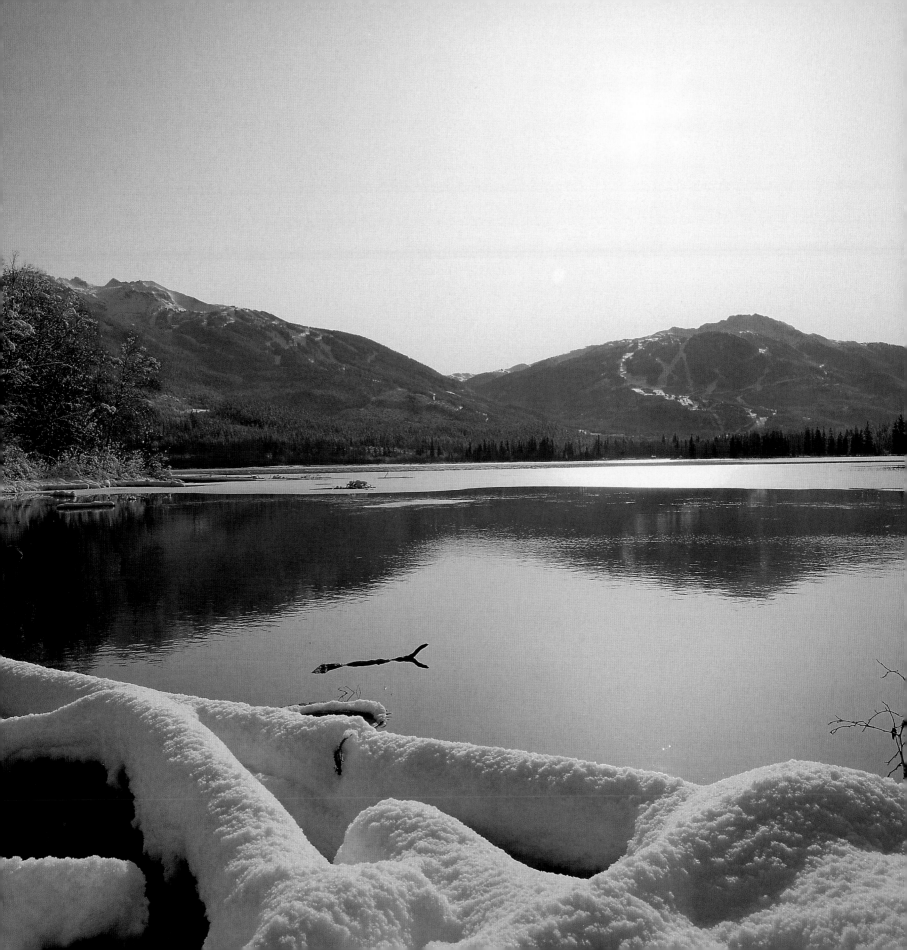

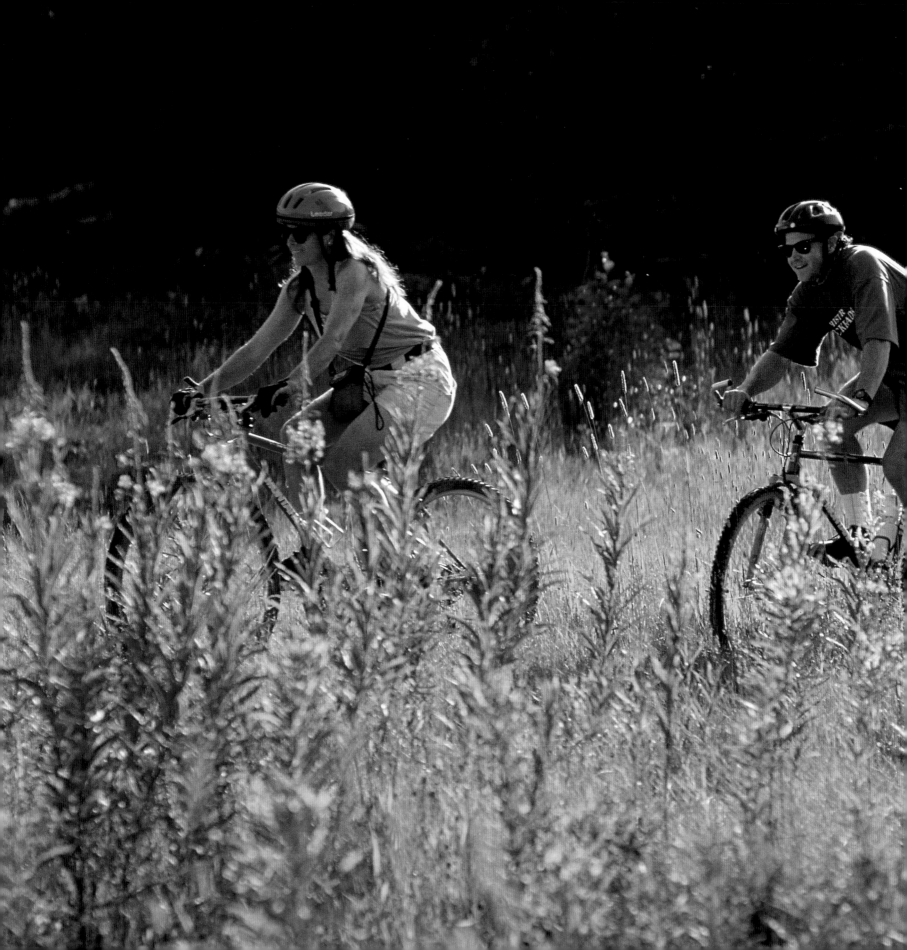

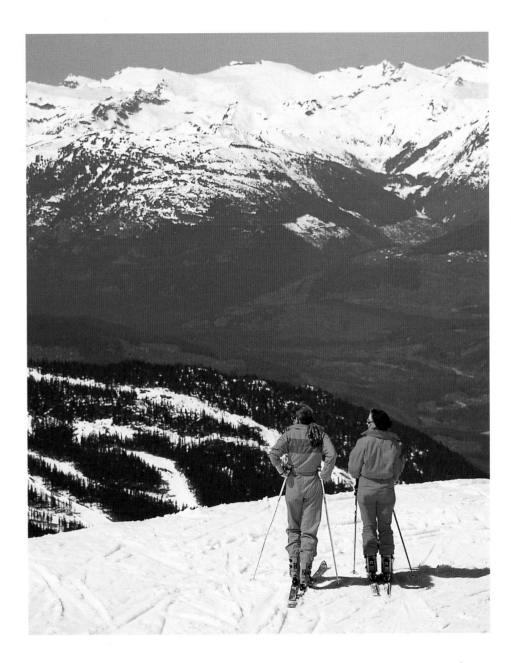

Whistler/Blackcomb is known for women's ski programs, ranging from beginner snowboarding to advanced guiding and coaching.

Cycling trails lead to numerous picnic spots throughout the valley.

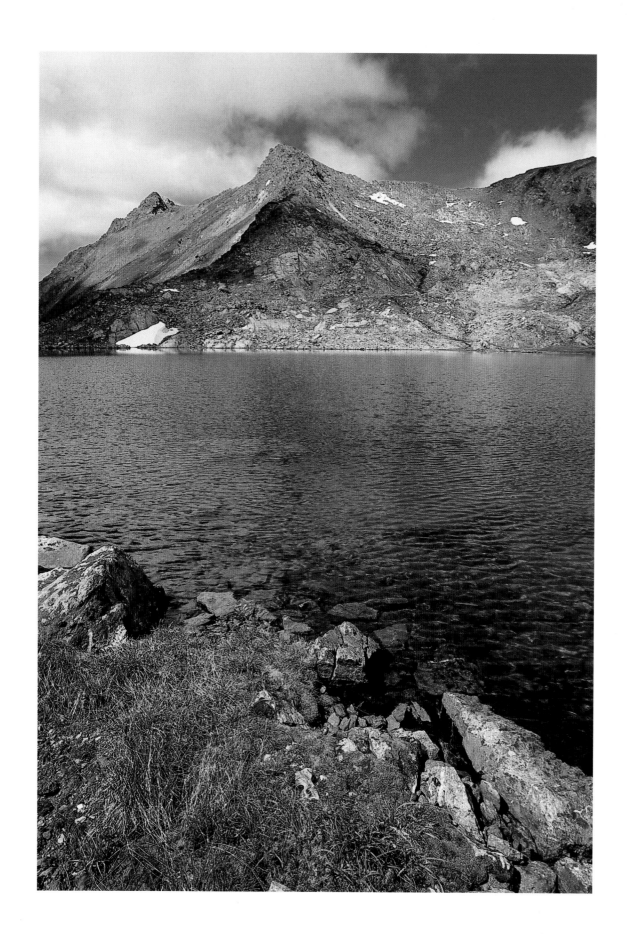

The icy blue of
Upper Twin Lake
sparkles in the
afternoon sun.

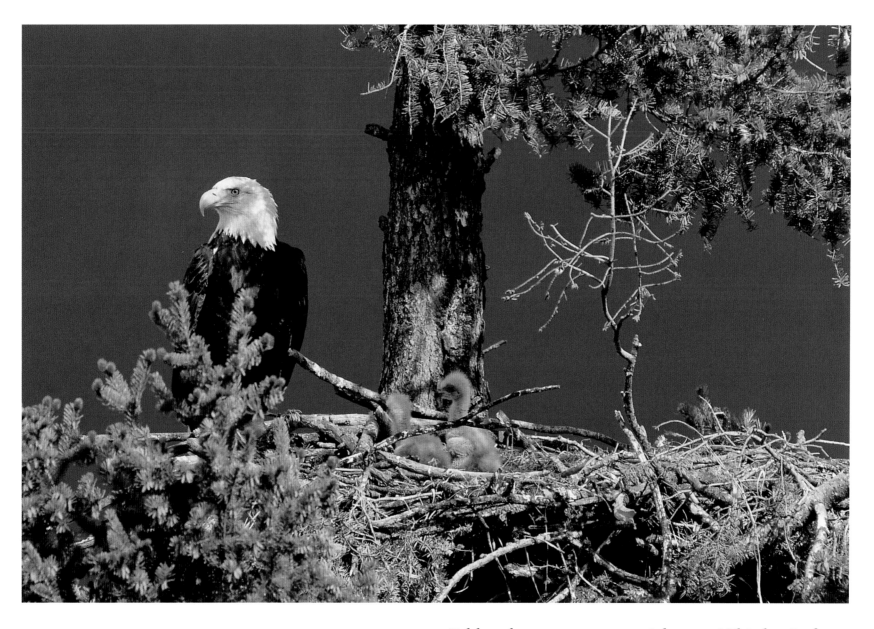

Bald eagles are a common sight near Whistler. In fact, Brackendale, just south of Whistler in the Squamish Valley, is one of the world's largest winter habitats for these majestic raptors.

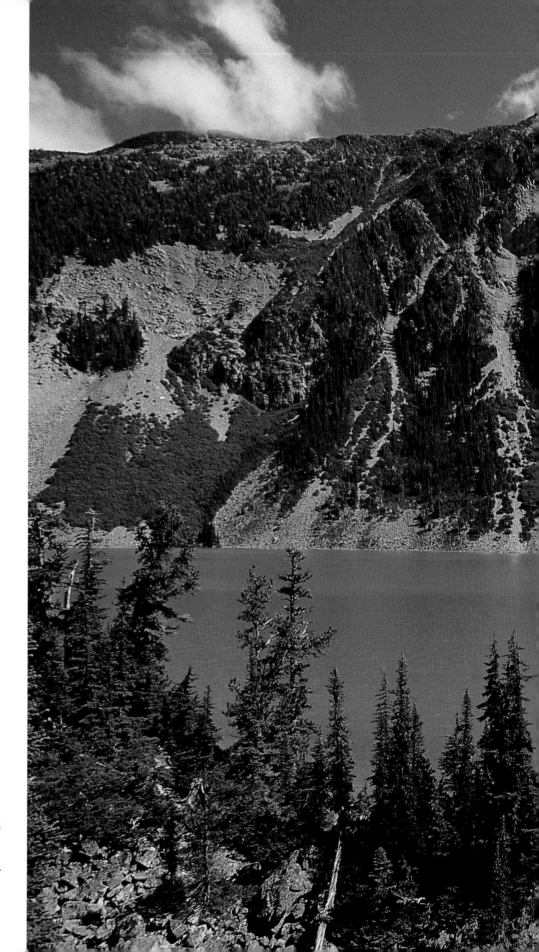

The three-hour hike to Upper Joffre Lake begins near Pemberton, north of Whistler. Hikers are rewarded with the crashing of ice as Matier Glacier feeds into the emerald lake.

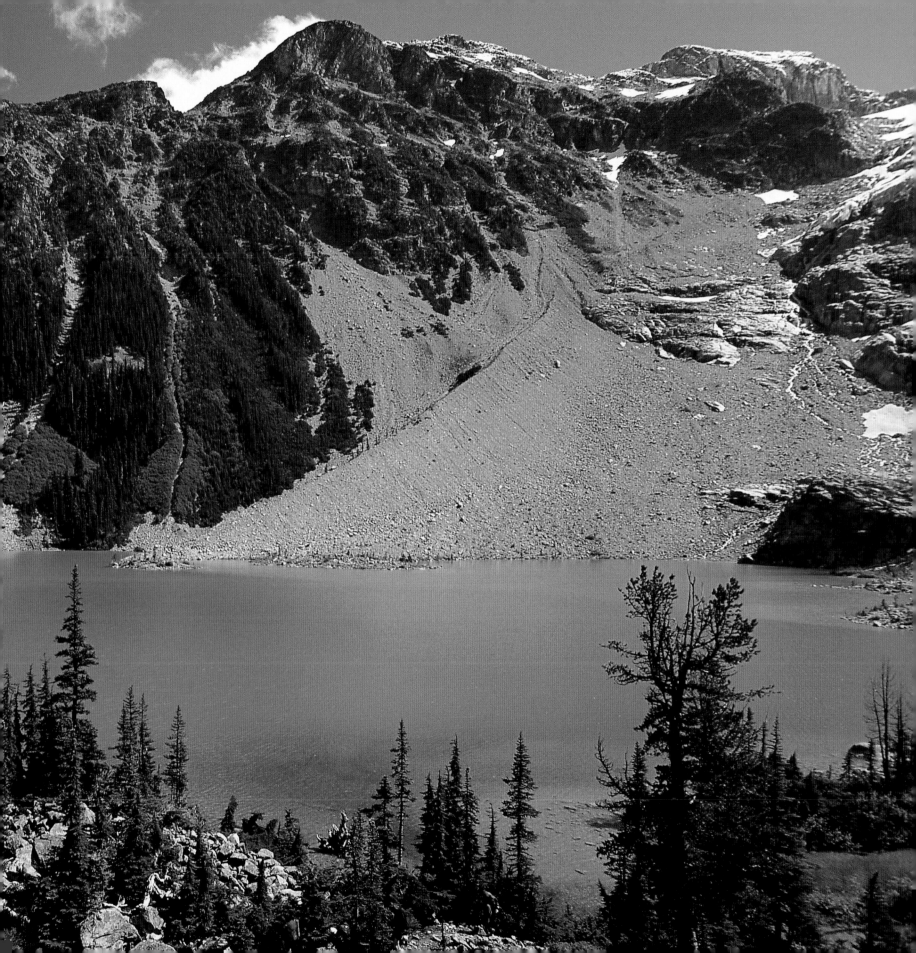

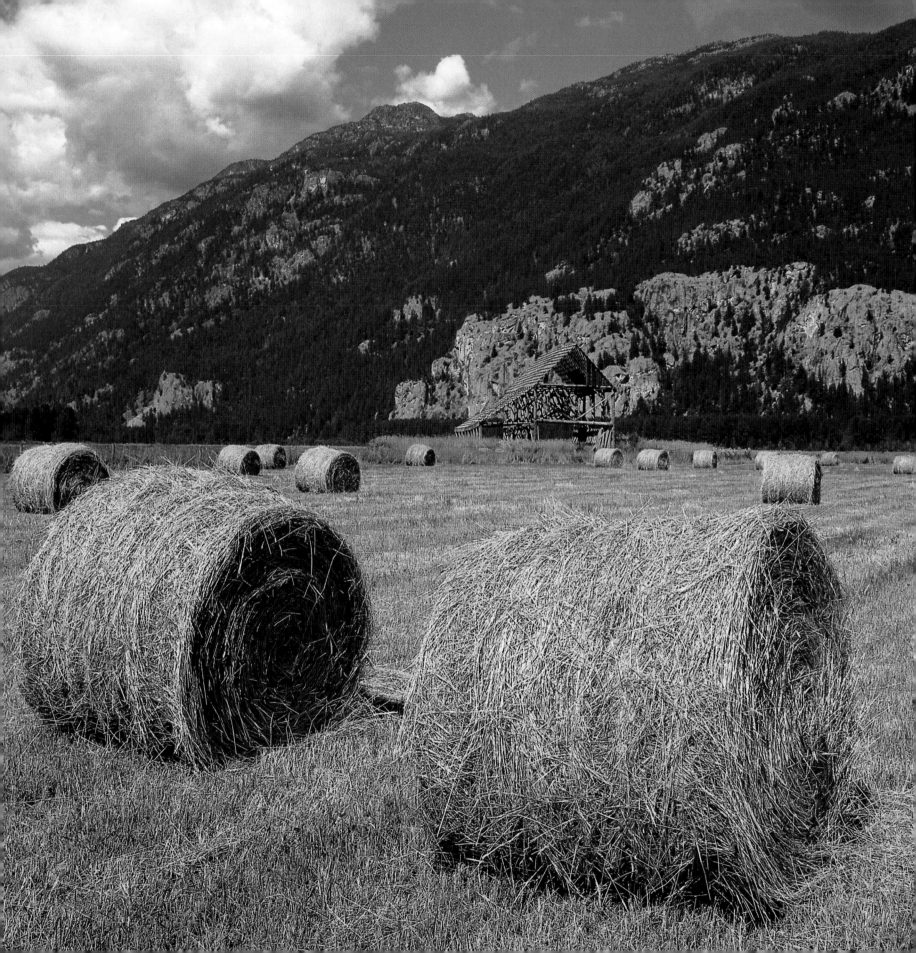

The agricultural areas surrounding Pemberton ensure a wealth of fresh produce for summer visitors.

FACING PAGE—
The town of Pemberton has strong roots in farming, ranching, and logging. The expansion of Whistler, however, has brought more people to the valley and made Pemberton one of Canada's fastest-growing communities.

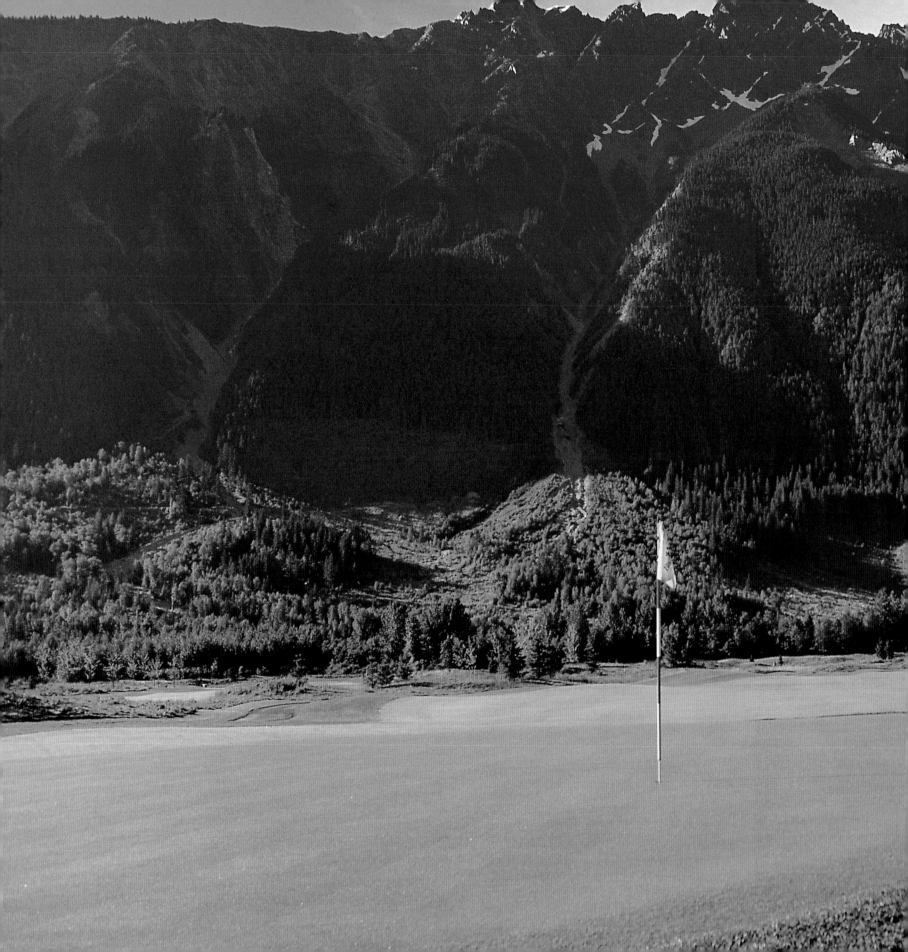

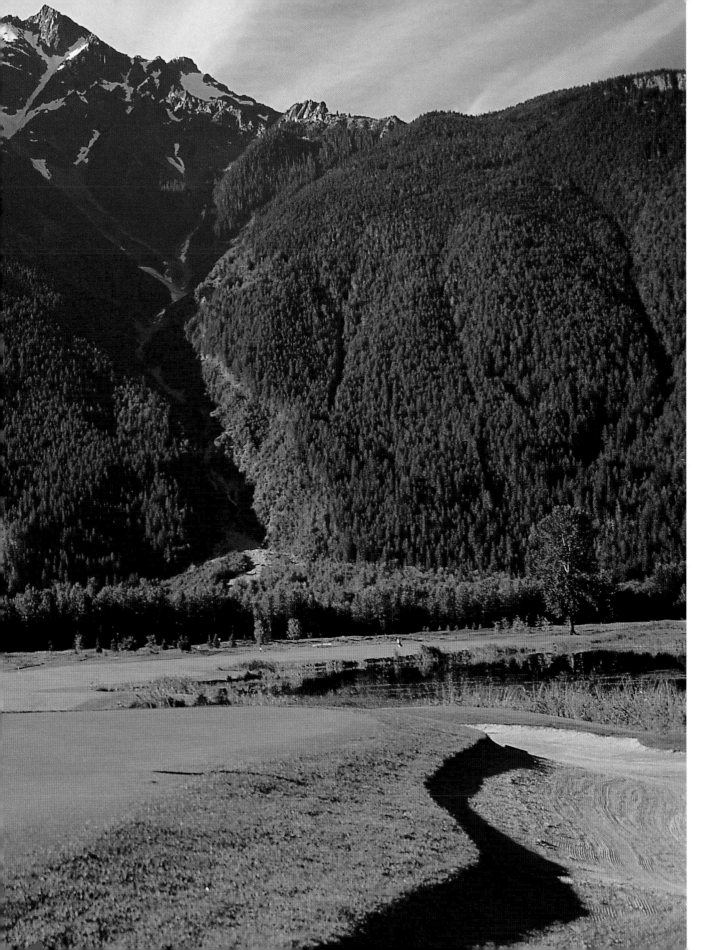

Big Sky Golf and Country Club in the Pemberton Valley was designed by award-winning course architect Robert Cupp, a former designer for Jack Nicklaus.

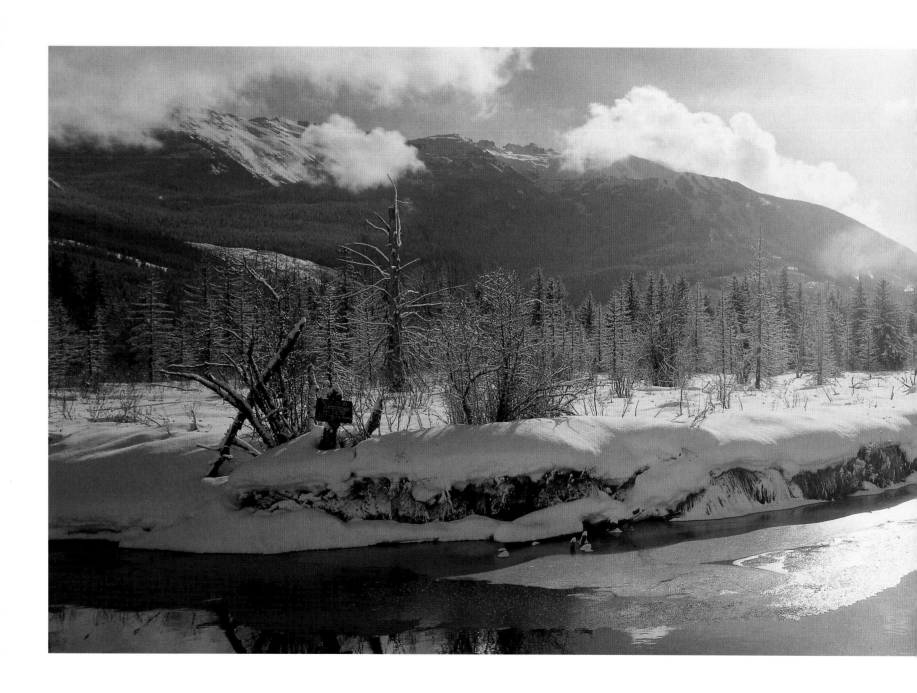

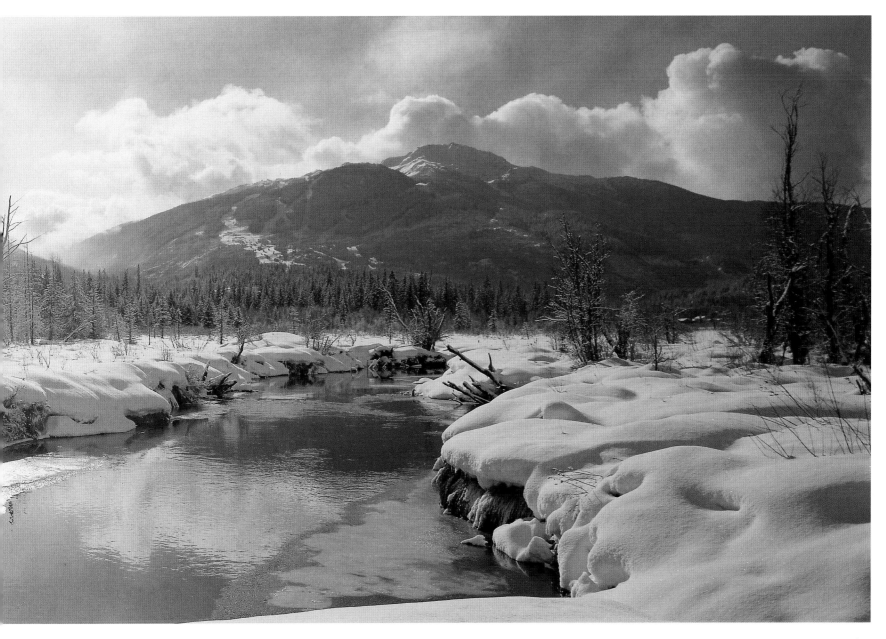

Contrary to what this chilly scene suggests, the Coast Mountains are part of a volcanic chain known as the "Rim of Fire," which circles the Pacific Rim.

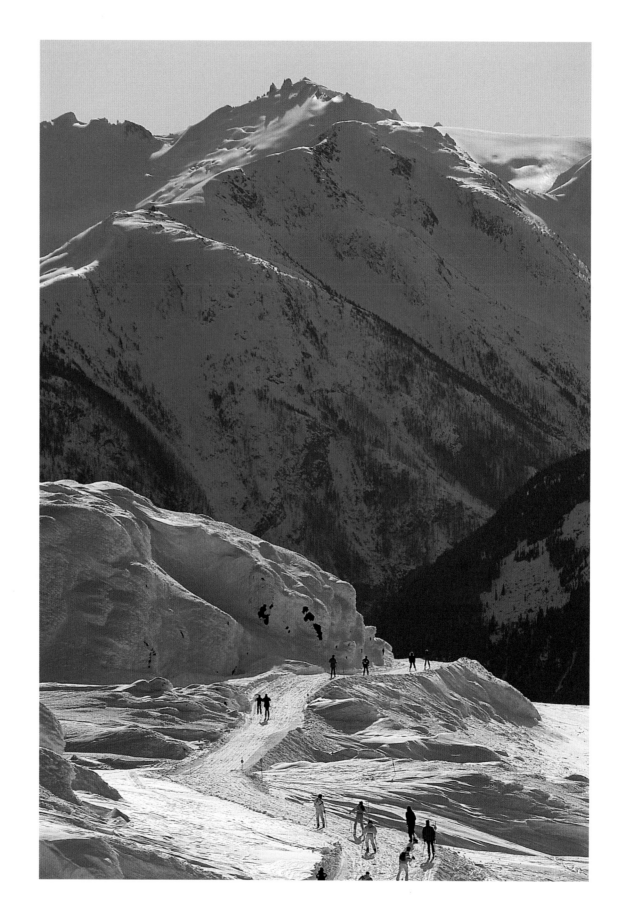

A mild average winter temperature of −4°C makes a long cross-country ski expedition an enjoyable way to spend a sunny afternoon.

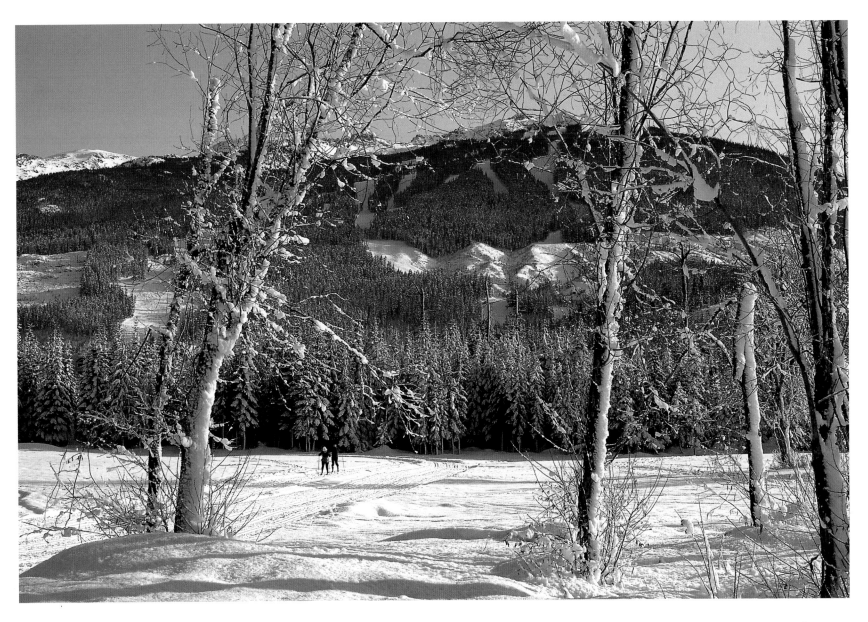

More than thirty kilometres of cross-country trails lead skiers around Lost Lake, the Chateau Whistler Golf Course, and Green Lake Golf Course.

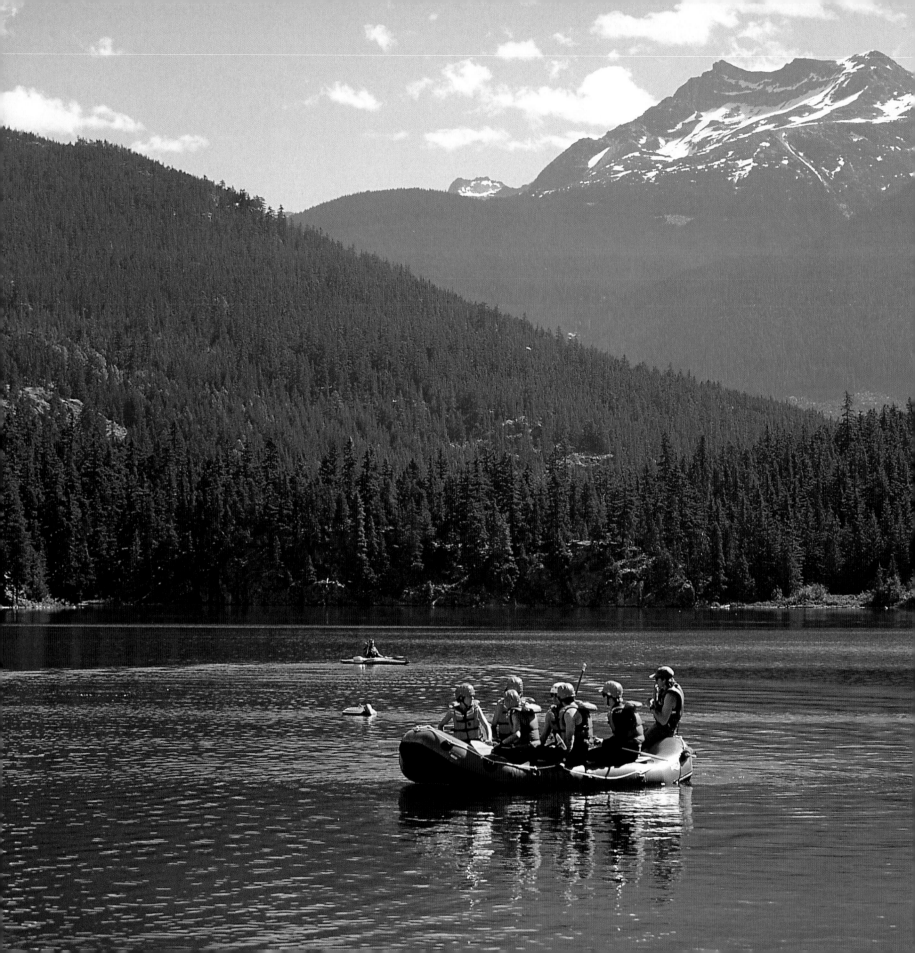

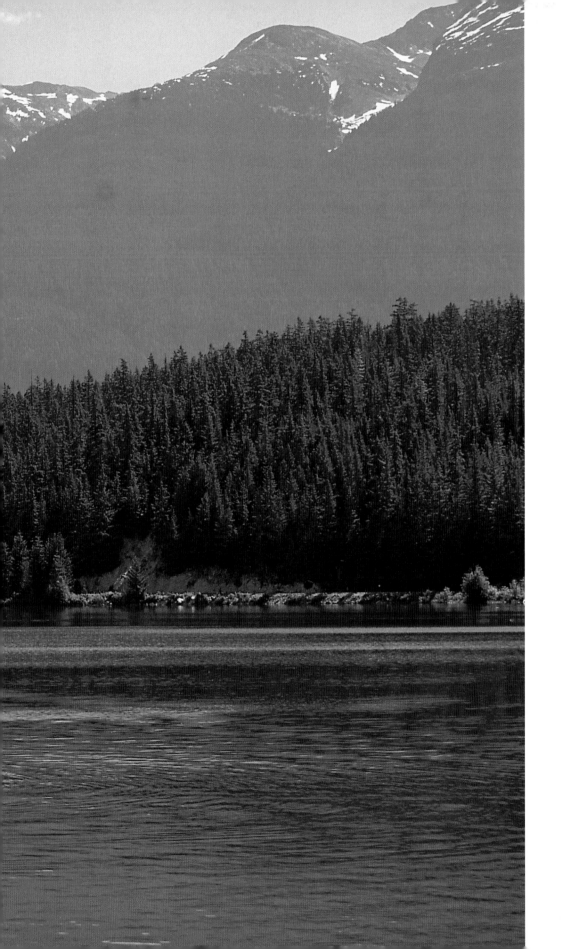

Visitors can choose a more serene rafting trip, or a journey through rapids with names such as Disaster, Steam Roller, and Devil's Elbow. On the Squamish, Mamquam, Green, or Cheakamus rivers, adventure is just a few bends away.

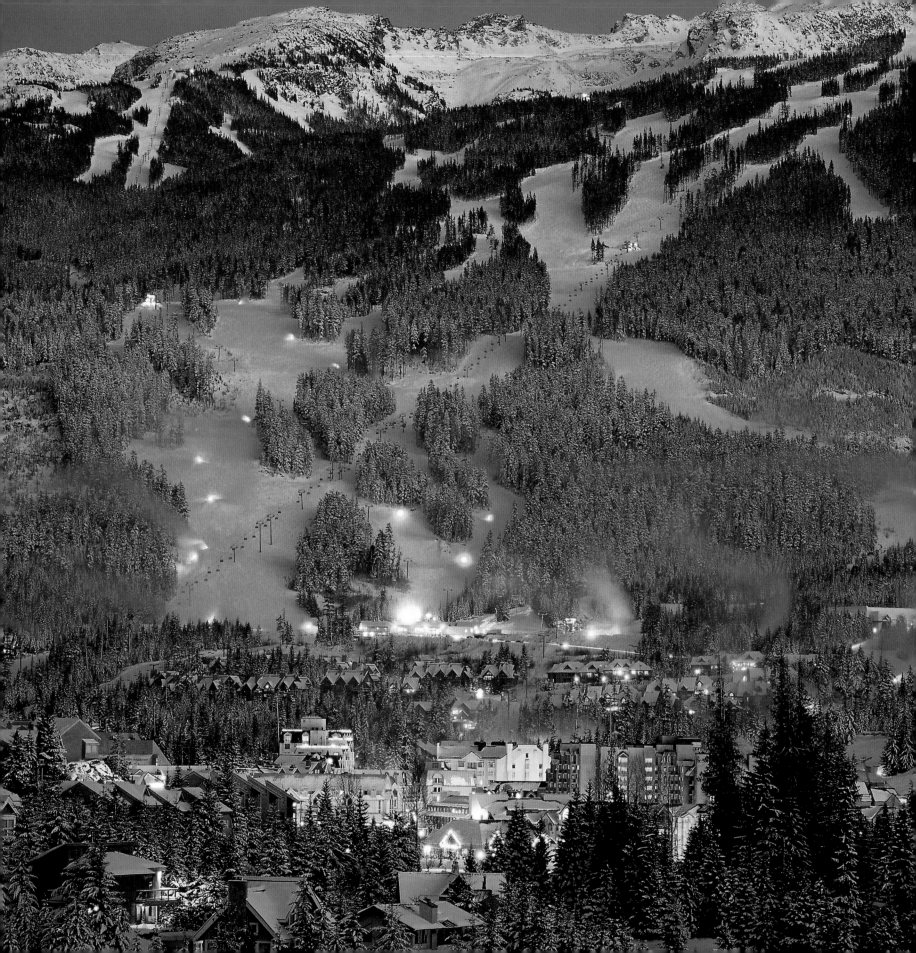

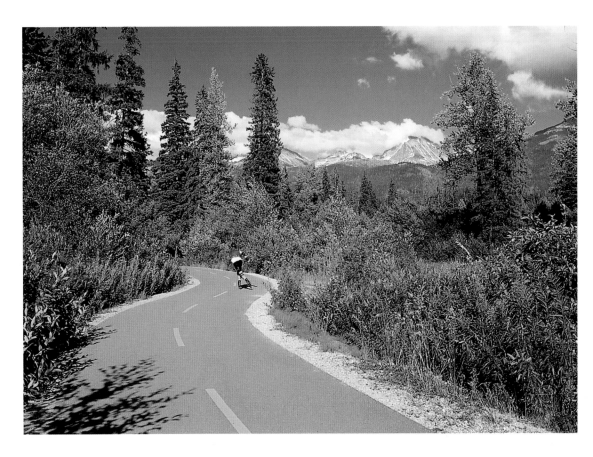

The popularity of in-line skating has boomed in the last few years, and the Whistler area's paved valley trails and quiet back roads make it the perfect venue.

Whistler Village has developed rapidly in just a few decades—it has only had electricity since 1964.

Alta Lake is the traditional boundary between the First Nations of the Squamish and Lillooet regions. Hudson's Bay Company explorers named it Summit Lake in the mid-1800s. The name was later changed to Alta, which means summit in Spanish.

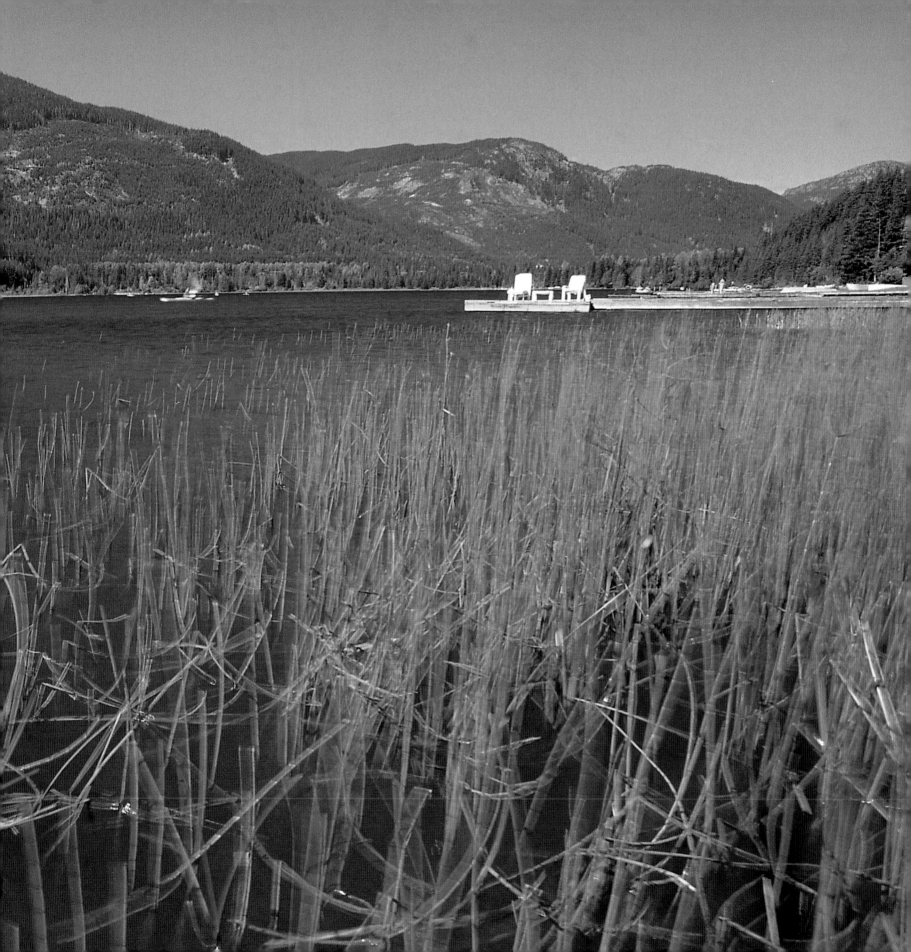

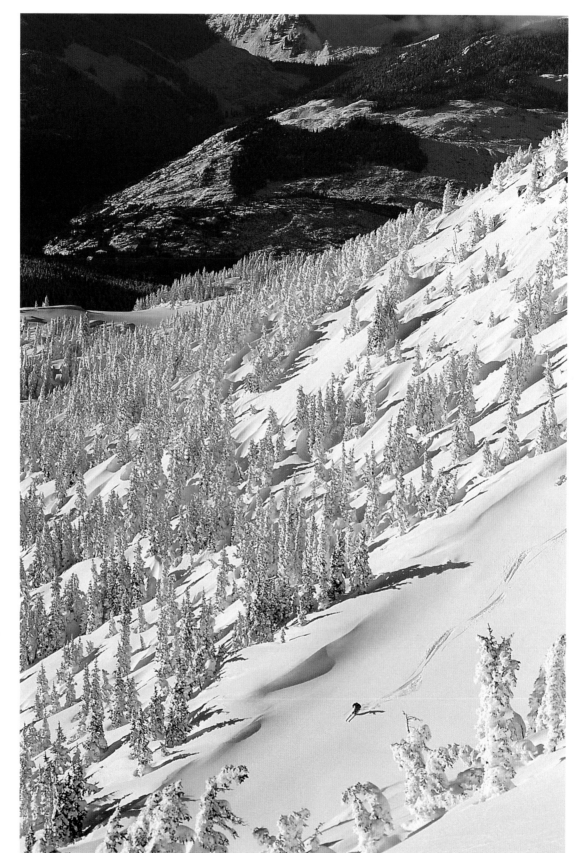

It has never been so easy to hit the slopes. The trip from Vancouver to Whistler was once a five-hour journey along a one-lane road. Now it's an easy two-hour drive. The lift ride from the base of Blackcomb to Rendezvous Lodge has dropped from forty-five minutes to fifteen, thanks to high-speed lifts.

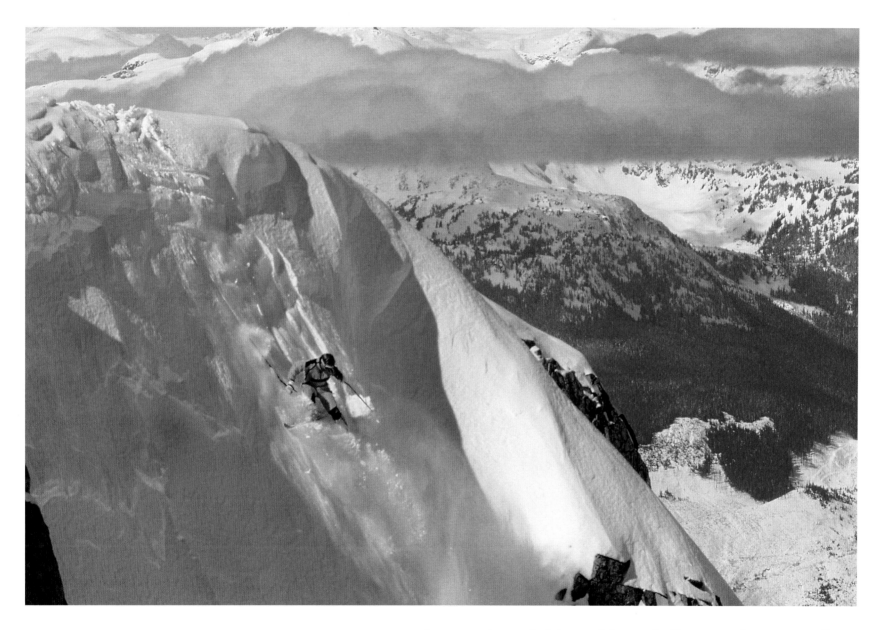

An experienced skier tackles a challenging drop, one of many that make this area a favourite with extreme skiing and snowboarding fans.

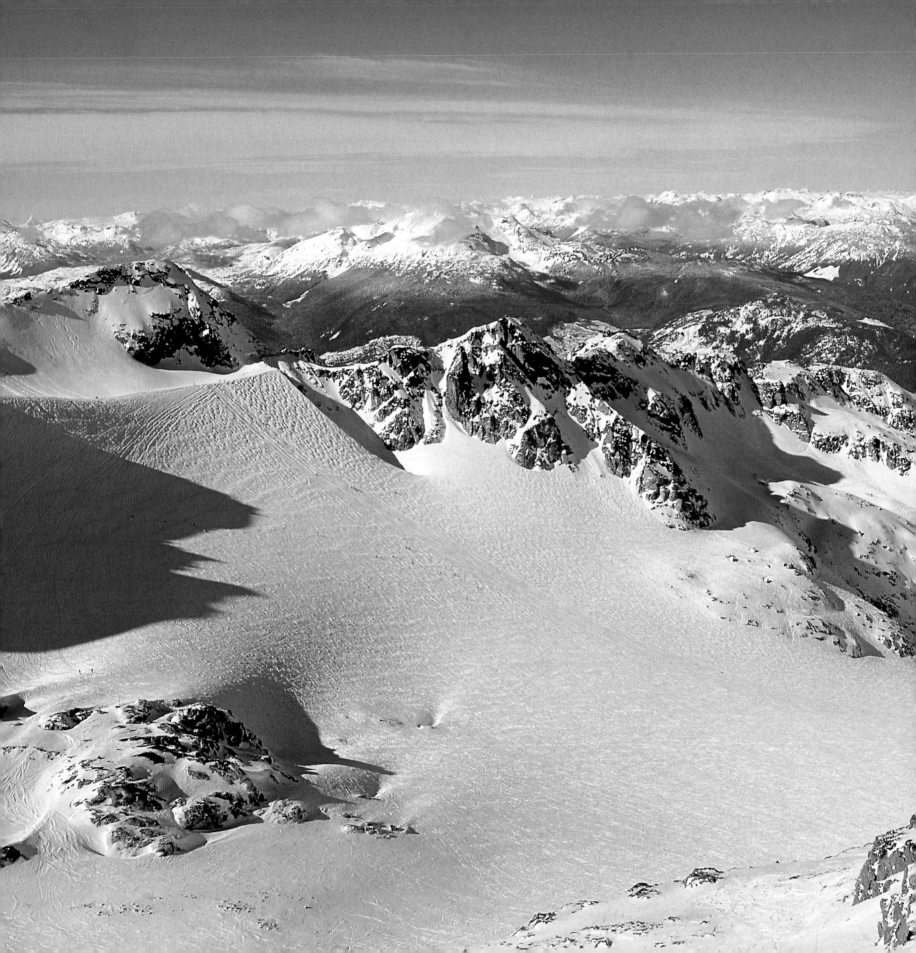

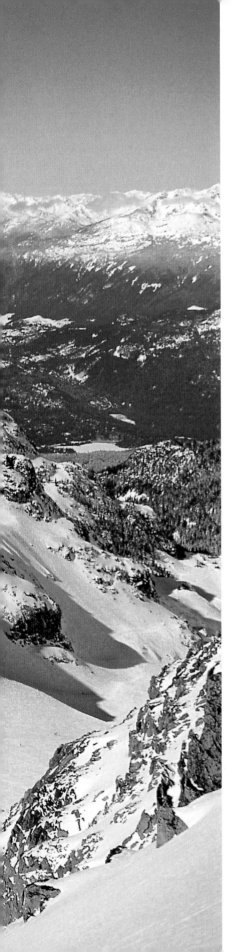

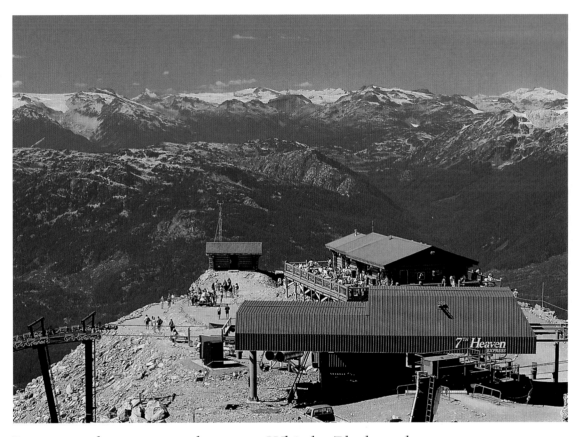

Intrawest, the company that owns Whistler/Blackcomb, owns resorts across North America, including Quebec's Tremblant and Mont Ste. Marie, West Virginia's Snowshoe, and California's Mammoth.

Three lift-accessible glaciers are just part of the reason *Snow Country Magazine, Ski Magazine,* and *Skiing Magazine* have named this North America's top resort.

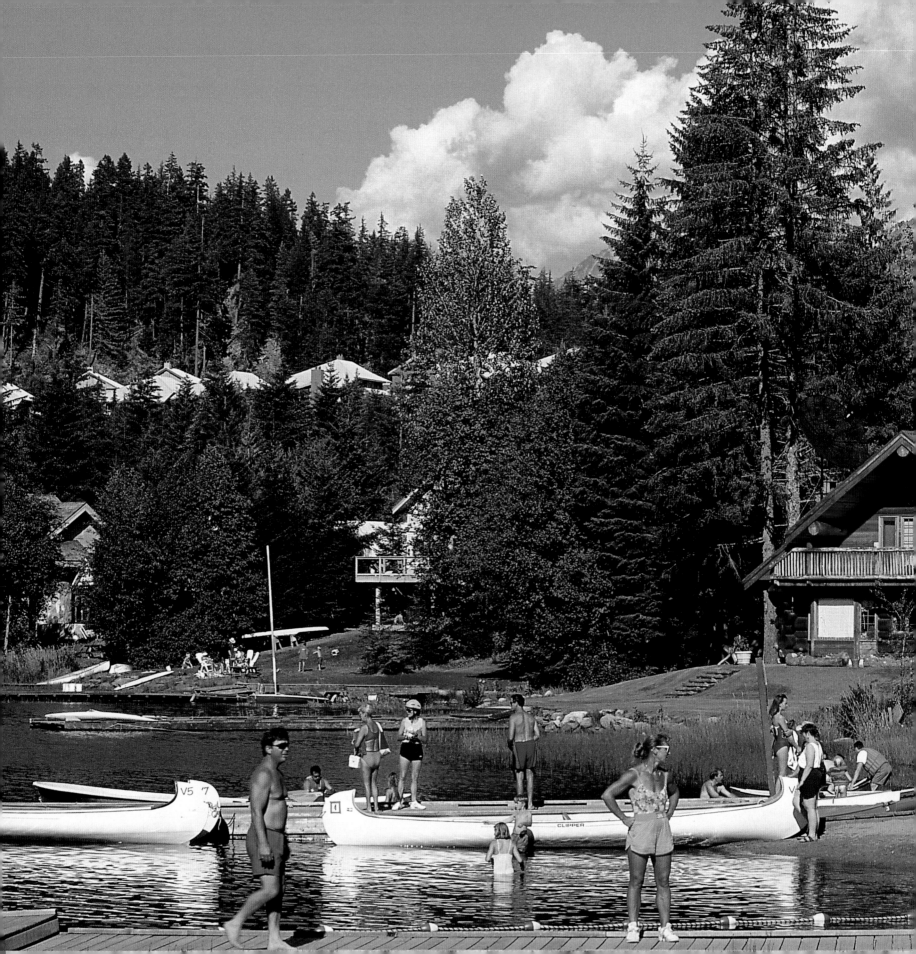

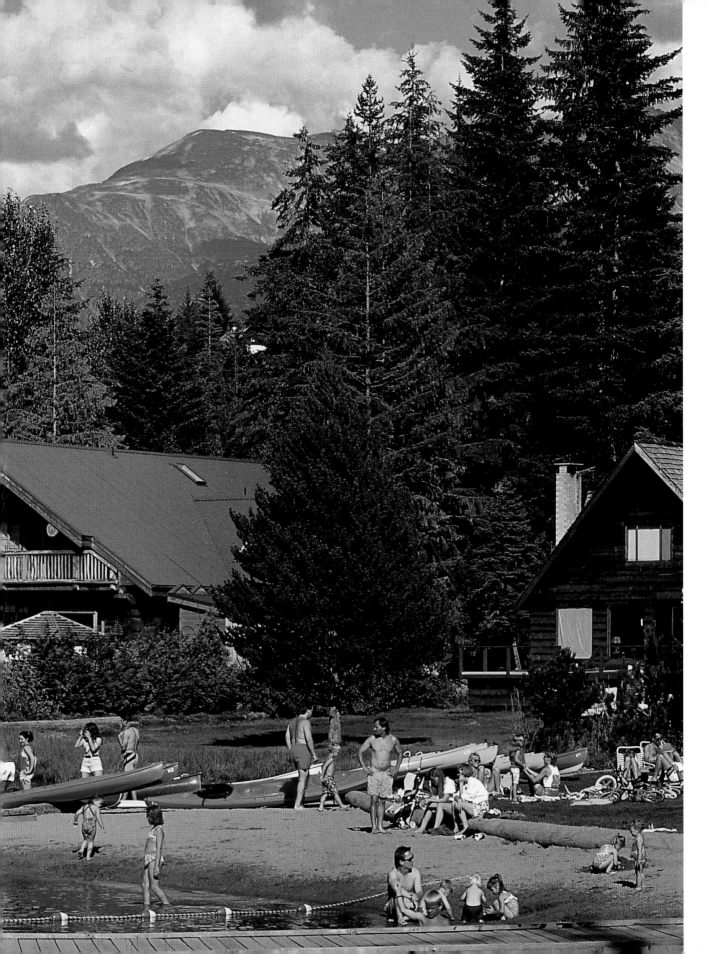

Rent canoes, play tennis or volleyball, sunbathe, or watch children explore the miniature hobbit house—Alpha Lake offers almost every possible summer recreation activity.

Photo Credits